WHAT THEY'RE SAYING ABOUT ROCKY STORIES

"The Rocky Steps have become a special place for tourists and Philadelphians alike. Virtually everyone who lives here or comes here wants to say that they ran up the Rocky Steps and saw the incredible view down the Benjamin Franklin Parkway. When I was Mayor, the city planned twenty-four hours of millennium celebrations, one each hour. Of course, we had to kick it off at the Rocky Steps, and we did so with two thousand people all dressed like Rocky running up the steps at the same time. It was awesome."

– Pennsylvania Governor Edward G. Rendell

"In our increasingly homogenous world of strip malls and chain restaurants, there are still a few authentic and unscripted experiences left. One of them takes place every day on the towering steps of the Philadelphia Museum of Art, where strangers flock from across town and across the globe. Two extraordinarily talented journalists, Michael Vitez and Tom Gralish, have captured this uniquely American phenomenon with whimsy, poignancy, and utter charm. *Rocky Stories* will steal your heart and restore your faith in the power of shared human experience."

– John Grogan, author of *Marley & Me*

"Combine Pulitzer Prize-winning writer Michael Vitez with Pulitzer Prize-winning photographer Tom Gralish, let them loose on one of the great architectural icons of the modern world and what do you get? A book that is an absolute joy and an absolute blast and quintessentially American in its hopes and dreams and sweetness."

– Buzz Bissinger, author of *Friday Night Lights*
and *A Prayer for the City*

"I ran the steps holding the hopes and dreams of the entire nation in my right hand. With each stride I heard my name, and with each breath felt pride. When I finally lit the cauldron with the flame from the Olympic torch, I knew I had arrived. Michael Vitez and Tom Gralish have brought to life the many amazing and beautiful personal stories from Philadelphia's art museum steps. The Rocky Steps finally have a voice."

– Dawn Staley, Olympic gold-medalist and Temple University
women's basketball coach (on carrying the Olympic torch
up the Rocky Steps)

"*Rocky Stories* captures the sprawling complexity of life. It's a delight."

– Mark Bowden, author of *Black Hawk Down*
and *Guests of the Ayatollah*

★ ★ ★ ★ ★ ★ ★ ★ ★

In *Rocky Stories*, Michael Vitez and Tom Gralish present fifty-two profiles of "Rocky runners." If you've run the Rocky Steps, visit www.RockyStories.com and share your *Rocky* story with us.

ROCKY STORIES

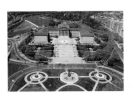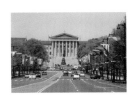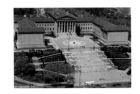

ROCKY STORIES

Tales of Love, Hope, and Happiness at America's Most Famous Steps

By Michael Vitez

Photographs by Tom Gralish

Foreword by Sylvester Stallone

PAUL DRY BOOKS

Philadelphia 2006

First Paul Dry Books Edition, 2006

Paul Dry Books, Inc.
Philadelphia, Pennsylvania
www.pauldrybooks.com

All photographs by Tom Gralish, except as follows:
Michael Vitez pp. 47, 57, 58, 61, 63, 74, 77, 81, 85, 86, 89, 90, 94, 96, 101, 110;
Miffany Henley & Richard Brock p. 118

Designed and composed by 21xdesign.com

1 3 5 7 9 8 6 4 2
Printed in China

Library of Congress Cataloging-in-Publication Data

Vitez, Michael.
Rocky stories : tales of love, hope, and happiness at America's most famous
steps / by Michael Vitez ; photographs by Tom Gralish ; foreword by Sylvester
Stallone. — 1st Paul Dry Books ed.
p. cm.
ISBN-13: 978-1-58988-029-0 (alk. paper)
ISBN-10: 1-58988-029-3 (alk. paper)
1. Success. 2. Rocky (Motion picture) I. Gralish, Tom, ill. II. Title.
BJ1611.2.V59 2006
158.109748'11—dc22
2006015860

ISBN-13: 978-1-58988-029-0
ISBN-10: 1-58988-029-3

CONTENTS

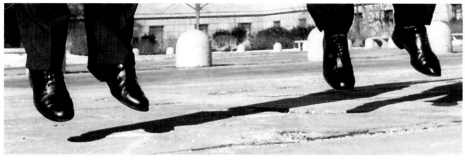

3-27-18

FOREWORD

by Sylvester Stallone

I spent a lot of time in Philadelphia in the 1960s, and even though I worked along the waterfront area, I went to school at Lincoln High. That's why I used Fishtown for Rocky's home turf. And when I ran along the waterfront there, with the ship in the background, it's because I used to work down there.

But the steps were like a magical area. It was like this intellectual bastion that I would only look at from afar. It almost seemed like another city, like the Acropolis. It was just some incredible monument. I thought, when I went back there, what would be interesting is what defined who Rocky is. We've seen him in squalor. He eventually runs from all this squalor, poverty, and he decides that the pinnacle of what will determine his success will be whether he is able to run up the steps of this magnificent structure—a structure where he really doesn't even understand what's inside, but only what it represents. It's like he's crossed over to a new dimension, a new status. And the first time he tries to go up there, obviously he fails, he's not qualified. I think what's burned into people's memories is that it wasn't so easy the first time. It required him to go back, rethink, train. And then finally, that is the last piece of the puzzle which will complete his transformation.

What I remember about filming it is we didn't have the union's permission, so we had to steal the scene basically. Originally I wrote it with him trying to ascend the stairs carrying his dog, Butkus, who weighed about 120 pounds. After going up a flight and a half, I realized I would only be completing this with a terminal case of a hernia, so I abandoned that idea. The main thing was trying to get there very early in the morning to avoid any of the union observers that would have shut us down, and they did eventually. So it was sunrise—we got there before anybody knew we were there, ran up the steps with this experimental camera, and completed that journey. It was one of those things that just all fell into place. There was nothing pre-planned. There was no storyboarding. It was incredibly visceral.

Why people run there thirty years later? I think *Rocky* has represented something that, when you train for Rocky, you basically train for yourself. Because we are underdogs. And there's very few things, iconic situations, that are accessible. You know, you can't borrow Superman's cape. You can't use the Jedi laser sword. But the steps are there. The steps are accessible. And standing up there, you kind of have a piece of the *Rocky* pie. You are part of what the whole myth is. I think it's something that will endure. And I'm just glad to have stumbled upon the idea and come up with *Rocky*, which is basically a euphemism for the city of Philadelphia. ★

A YEAR AT THE STEPS

One day not long ago, a taxicab pulled up to the curb in front of the Philadelphia Museum of Art. A man hopped out and started running up the steps. A woman jumped out after him and began filming him. He sprinted to the top, turned to face the city below, and danced and pranced and thrust his fists into the air in celebration, just as if he were Sylvester Stallone in the film *Rocky*. The man then ran back down the steps, hugged his girl in jubilation, and together, arm-in-arm, they skipped—skipped—back to their taxi.

I reached them just as the cab was pulling away.

Where are you from?

"England," said the man.

How long have you wanted to do this?

"All my life."

This kind of thing happens all the time, every day of the year. From all over the Philadelphia region, the nation, and the world, people are drawn to these steps to run them as Rocky did. The movie premiered in 1976, thirty years ago, yet they still come—a high-school track team from Belfast, three busloads of professional wrestling fans from Australia, a college rower from Maine, a librarian and her fiancé from Lake Tahoe, two best friends who grew up in Oklahoma, a race car driver from Pennsylvania (he ran the steps for good luck). The story of *Rocky* inspired them, stirred them, and they felt they had to come here, like the movie hero, and share this literal and cinematic high.

Mark Glazier, a welder from British Columbia, ran the steps with a tear in his eye. "Everybody knows what it is that brings you here," he told me. "It's the feeling, man. You come here for the feeling, that

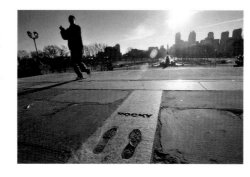

you can accomplish something, that anybody can accomplish anything they want with hard work. I've wanted to come here for many years."

During the twenty years I have lived in the Philadelphia area, I have seen people from all over the world come here and run the steps. As they run, and when they reach the top of the museum steps, they all share a certain momentary joy. I wanted to capture this joy, explain it, celebrate it with stories and pictures, and share it. My decision to write this book was based on an intuition that I would find wonderful stories here. What I discovered, after spending a year at the steps, was even better than I had expected. The world, increasingly, is filled with chaos, sadness, madness, and hate. The "Rocky Steps" (as they have come to be known) offer an escape from that, if only for a few moments. Even better, they offer a tonic to the world's problems, a chance to celebrate hope. People come here and affirm their dreams. *Rocky* may have brought them here, but it is their own lives that they celebrate.

Almost everyone who comes here knows the fictional story of Rocky Balboa, the boxer from Philadelphia's Fishtown neighborhood: Rocky is thirty years old, pretty much washed up as a fighter, scraping by as a tender-hearted leg-breaker for a loan shark. He sees beauty where no other man does, in the shy and homely Adrian (played by Talia Shire, in an Oscar-nominated performance), who works at the local pet shop. But in the beginning of the movie, he is going nowhere with her, just as with the rest of his life. Then he gets the call.

Apollo Creed, the heavyweight boxing champion of the world, is scheduled to defend his title in Philadelphia on New Year's Day in 1976, but his opponent drops out just six weeks before the fight

because of an injury. Apollo decides to honor the nation's Bicentennial and the American spirit by giving an unknown fighter a shot at him and his title. He chooses Rocky. And why? Because of his nickname, "The Italian Stallion." Filled with self-doubt, Rocky at first declines the million-to-one shot—he resists the call, as movie heroes so often do—but finally he accepts. And beginning with his relationship with his manager, Mick (played by Burgess Meredith, who was also nominated for an Oscar), Rocky undergoes a remarkable transformation—as a man, a friend, and a fighter.

Rocky's goal is not to win the fight, but just to go the distance, to last all fifteen rounds and prove to the world, and to himself, that he is not "just another bum from the neighborhood." Along the way, he wins the love of a woman and develops friendships without which he never could have succeeded. And he learns that, without this love and these friendships, success would have no meaning. Rocky overcomes the odds, redeems himself, and realizes the American Dream. The real glory for him is not in winning, but in striving to be his best.

No scene in *Rocky* is more symbolic, more powerful, or more enduring than the one at the art museum steps. Earlier in the film, Rocky sets out on a training run, but he is so out of shape that by the time he reaches the museum he can't even jog to the top of the steps. He has to walk. Near the end of the movie, on the eve of the big fight, he tries again. This time, though, he has changed. He has worked so hard, improved so much. He leaves his dreary row-house apartment, runs through the Italian Market, past the burning barrels of trash that merchants used to warm themselves, sprints along the docks, and finishes by racing up the museum steps at dawn, taking them three and four steps at a time, celebrating with a spirit and verve that still draws throngs to that very spot, in real life, three decades later. At the top, he spins and dances and thrusts his

fists into the air, an action and gesture for which I have coined the verb *to rocky*. He isn't celebrating victory; this scene takes place before the fight. He is celebrating something more important—how far he's come in life. The steps become a symbol of his journey, his triumph—our triumph.

Most of the people who run the Rocky Steps understand that the movie, in its own kitschy, corny, classic way, represents what is great about America. An Everyman can make his dream come true; an underdog can triumph through hard work; and few things are possible or worthwhile in life without love and friendship. People want to believe the American Dream is still true, still possible, for themselves and for everyone. Actually, this desire transcends nationality. It is not just an American dream, but a universal one.

And because of a remarkable serendipity of architecture, history, and cinema, the people can come to this spot and bring that dream to life. They don't have to have much in common with Rocky; they may not even especially like the movie. But the sense of joy, self-expression, and hope that everyone feels as he or she celebrates on the steps is unmistakable and undeniable.

People feel part of something here. They can visit the Liberty Bell, sure, but they can't hear it ring. At the steps, for a moment, they can actually touch the American Dream. They can bond with the thousands and thousands who have run before them, and with the fictional hero whose

cinematic journey symbolizes their own. Making a run up the Rocky Steps has become a national, and international, rite of passage.

Many people don't know why they run; they just do it. Some may think of it as just another touristy activity. But as they run, as they reach the top, they feel the exhilaration. "It was a little bit surreal," said Sasha Sutcliffe-Stephenson of Minnesota, in Philadelphia with friends who were students at Carleton College. "And, at the risk of sounding sappy, while I was running, I felt as though I was taking part in something bigger than just me."

I heard this sentiment over and over. It is not Rocky Balboa's life that runners are celebrating, but their own. They are all at various stages of their own journeys, many still at the bottom, just beginning the climb. Others have already overcome amazing things: drug addiction, cancer, a heart transplant.

John Monforto has run these steps hundreds of times. He is a Rocky impersonator who has made a living leading conventions of orthodontists and estate planning lawyers on runs up the steps. "It's our opportunity to connect with or to touch fame," said Monforto. "The success of the *Rocky* movie was the underdog having his chance at the big time. When you see the steps, it's like being in the movie. It's exhilarating. It's almost as if you made it big by reaching the top of the stairs."

It would be hard to overstate the dramatic impact that *Rocky* had in the United States when it was first released in 1976. It was filmed in just twenty-eight days, on a budget of $1 million—one-tenth the average cost of a Hollywood movie of that era—but audiences did not seem to mind. Sylvester Stallone stole the nation's heart, a complete unknown, so broke he had contemplated selling his dog to earn a few extra dollars. He wrote the script in three days and was offered $250,000 for it—at a time

when he had all of $109 in his checking account—but he refused to sell the script unless he could play the part of Rocky Balboa. Naturally, the producers wanted a big-name star; they had in mind James Caan, Burt Reynolds, Ryan O'Neal. But Sylvester Stallone, with the fortitude of the character he had created, held his ground. And his resulting rise to fame and glory in real life was even more remarkable than that of Rocky's onscreen.

Stallone was only the third person to be nominated for Academy Awards for best actor and best screenplay for the same film. (Charlie Chaplin and Orson Welles were the others.) And while he won neither of those honors, *Rocky* did win the Oscar for best picture, beating out *All the President's Men*, *Network*, and *Taxi Driver*. As Carrie Rickey, film critic for the *Philadelphia Inquirer* wrote, "*All The President's Men* is of its time. And *Rocky* is timeless, one man beating the odds." *Rocky* received a total of eight Oscar nominations and won in two other categories, for best directing and best film editing. The April 11, 1977, issue of *Newsweek* featured Sylvester Stallone on the cover and sported the headline "ROCKY KOs HOLLYWOOD."

"We always talk about phenomenons," film historian Jeanine Basinger, a professor at Wesleyan University, told Carrie Rickey when she wrote about the twenty-fifth anniversary of the film in 2001. "*Rocky* really was one. It made Stallone a star. It made the Horatio Alger story, tarnished and suspect during Vietnam, credible again. And it turned Stallone, the gallant pug who taught the rest of the country to say 'Yo!', from a nobody into a businessman. He saw the franchise possibilities in *Rocky*. And remember, this is before *Star Wars*."

Rocky earned $117 million in its first year. The series of five *Rocky*s has earned more than $500 million in America alone. In 2007, Sylvester Stallone will release *Rocky Balboa*, the sixth Rocky film. In it, our hero

emerges from retirement at the age of sixty and returns to the ring—and also, of course, to a scene at the art museum steps!

The image of that scene at the steps from the original film has endured, and been recreated by countless fans, Basinger told me, because "what happened there is a perfect example of great filmmaking." She continued: "When the guy comes up to the Philadelphia art museum, a bastion of establishment, of money, history, authority, and runs up to the top, and makes that physical expression, it totally encapsulizes in that image and with that action the meaning of the film, the meaning of his character, the metaphor for the story. Everything is right there. Plus it's got the music, the moving camera, he's looking good, and audiences give themselves over to it. Good movies try to make audiences participate, feel the victory, feel the action, put the audience in that place. Not just physically, but emotionally.

"The great thing about this is…you can be Rocky offscreen," she added. "That's the gift of *Rocky*. Most movies, you can only be Scarlet O'Hara onscreen, when you're in your seat. Here's a movie that could give you the same thing offscreen."

Rocky put Philadelphia on the map back in 1976 and kept it there. A city official in 1977 said *Rocky* "was the best thing to happen to Philadelphia's image since Ben Franklin." *Rocky* not only brought new attention to the art museum, it also defined Philadelphia itself, like no other movie before or since, as a city of working-class people with big hearts and big dreams—an image that has endured.

Perhaps Clark DeLeon, a former columnist for the *Philadelphia Inquirer*, said it best back in 1981, during the filming of *Rocky III*: "For millions of people around the world, *Rocky* is Philadelphia. And what they remember most is this mumbling, roughhewn, wholesome corner boy raising his arms in triumph, standing before the pinnacle of culture of his city. It is a magic moment that captured forever on film the best of Philadelphia, its majesty and its heart, its nobility and its people. You could spend a million dollars every week to promote Philadelphia with some slick advertising campaign, but nothing could touch as many people as that one scene."

This zeal has not abated. In 2000, when the Republican and the Democratic parties were considering holding their presidential conventions in Philadelphia, the site selection committees "both wanted to see the Rocky Steps," former Philadelphia Mayor, and now Pennsylvania Governor, Ed Rendell told the *Philadelphia Inquirer*. "They called them the 'Rocky Steps.' At the Republican Convention, I can't tell you how many walked up the steps and pumped their arms in the air."

Oprah has run the steps. Regis has run them. Allen Iverson has run them. The 2005 movie *In Her Shoes*, starring Cameron Diaz, Toni Collette, and Shirley MacLaine, featured two scenes at the steps—in homage to *Rocky*. Unhappy, lost, and stuck in her misery, the character played by Collette quits her job as a workaholic attorney and begins a personal transformation. She becomes a dog-walker as she tries to find meaning and happiness in life. Early in her transformation, she and her dogs run the Rocky Steps, but Collette, like Rocky, falters halfway up. Near the end of the movie, her transformation complete, she and the dogs run them again, and she "rockies" at the top, her arms filled with leashes.

Christopher Hendry, a student at Edinburgh University in Scotland, came to the steps the moment he arrived in Philadelphia. "The story's applicable to all cultures and all people because everyone at some point in their life felt like there was no hope, and no chance," he told me. "I suppose at times, no matter how small the situation may seem, you've always been the underdog…I've been a huge *Rocky*

fan since I was twelve years old. To actually be here, and see these steps, the whole place, it's amazing. I could really feel the spirit."

Dave Bauer, who vows to have the music from *Rocky* played at his funeral, dragged his family here from upstate New York and made them run the steps three times. He has loved *Rocky* for thirty years because, "When he was in the ring, he was fighting for the things that I believe in. He was fighting for both himself and the principles of the common man, and I am a common man. While Rocky was fighting in the ring, I felt like I was fighting with him. He was fighting for everyone who never got a chance in life."

The setting at the art museum steps is like the ocean; it changes every day. Sometimes, on glorious weekends, the Rocky runners come in waves, one after another: Catholic schoolchildren from California, Italian tourists, a busload of Korean English teachers. They are proud and unabashed—and *so* demonstrative. Other days, the scene is muted, more like a placid sea, and those who run might even be too inhibited to really "rocky." They might just raise their arms quickly, or not at all, content simply to study the bronze footprints cast at the top of the steps (the only physical tribute to the movie to be found there).

As one might expect, the more beautiful the weather, the more numerous the runners, but they come in any weather. Jon McClenaghan, from British Columbia, stretched for a moment one winter day, hands over his head, then touching his toes. He did a couple of one-two punches into the air, and then he was off and running. At the top, he turned to view the city below, raised his hands above his head, and bounced with glee. His true love, Lori Walmsley, captured him on video from the street, seventy-two steps below. He gazed out on the frozen, snow-covered city. "I can't believe nobody else is out here today," he said. I reminded him that it was ten o'clock in the morning on January 15, and the wind-chill was below zero. "Oh, it's nothing," he scoffed. "I'm Canadian."

The story, the actor, the camerawork, the music all played indispensable roles in making this one of the most famous and enduring scenes in film history. But so did, of course, the venue itself.

The Philadelphia Museum of Art is a glorious structure, built on the lines of a classical Greek temple, with wings embracing an open court, perched on a hill and constructed of yellow Minnesota dolomite that glows with a golden aura. The vibrant colors of the terra-cotta details along the rooflines still gleam in sunlight after more than seventy-five years. The museum overlooks the end of a wide, Parisian-style boulevard, the Benjamin Franklin Parkway, which cuts through the dense city center on a diagonal. The Parkway is one mile long, ten lanes wide, with flags of all nations flying along its length. There is a grand fountain in the middle, at Logan Circle. The Parkway was conceived at about the same time as the museum, which would become its terminal point. At the museum's dedication in 1928, former United States Senator George Wharton Pepper declared it "a temple erected to pure beauty in a community of diverse religions."

The Philadelphia Museum of Art houses one of the world's great art collections. Eight hundred thousand visitors enter every year, yet thousands of others come just to run the steps and never go inside. "The funniest thing," said Mike McMullen, a museum security guard who often perches by the steps, "is they come from all around the world to stand here, and they miss all the art in there."

The museum steps, the Rocky Steps, are simply grand. They number seventy-two in all, five flights of thirteen steps, with a landing between each flight, and a final flight of seven steps to the top. Each step is just five inches high, but fifteen inches deep—so deep and low they almost beg to be run. And after running each flight, one gets a moment to level out, regain steam, and attack the next one. In the climactic movie scene, Rocky runs these steps in just over ten seconds. He bursts up that last flight with one energetic leap to the fourth step, and then a hop to the summit.

"Those are classic dimensions for a big, formal, gradual stair," said David B. Brownlee, professor of art history at the University of Pennsylvania and author of *Making a Modern Classic: The Architecture of the Philadelphia Museum of Art*. "It's intended to make your ascent gradual and very gracious," he added. Many of the people who come to run are shocked, in fact, at how easy it is.

"I could have gone more," said Raman Dadayan, nineteen years old, of Los Angeles, after running the steps. "I mean, this isn't much." His mother confided that he had run the Los Angeles Marathon twice.

Still, the climb can leave those who are out of shape doubled over and winded, as it did the six South American tourists who tried it on New Year's Day. "Very hard, very tiring," said twenty-three-year-old Jose Davila, of Lima, Peru. "We had some drinks last night." But his brother, Ernesto, added: "We thought it was bigger than this. In the movie it looked bigger."

As renowned as the steps have become, they were almost an afterthought. "In the earliest designs for the building," David Brownlee said, "before the one that finally got built, the architects were playing around with no steps at all, and you'd go into a lower level lobby and be whisked up by elevator."

In fact, said Brownlee, the architects designed the stairs as a backdrop for the Parkway rather than as a legitimate entrance to the museum. "They didn't imagine people were going to stroll up from the city and then climb," he said. "They were for show...a piece of urban theater." Urban theater indeed!

Many people who run the steps still expect to find the statue of Rocky, created for *Rocky III*, at the top. Sylvester Stallone wrote, starred in, and directed *Rocky III*. In that sequel, Rocky Balboa has become the heavyweight champion of the world, and the City of Philadelphia honors him by erecting a statue of him at the top of the art museum steps. The fictional mayor declares at the statue's dedication: "This memorial...will stand always as a celebration to the indomitable spirit of man." But that was fiction. Reality was different.

The bronze statue stands eight feet, six inches high, weighs two thousand pounds, and reportedly cost fifty-three thousand dollars. It depicts Stallone in full "rocky"—arms raised in jubilation, fists clenched. The star intended to donate it to Philadelphia to remain permanently at the top of the Rocky Steps after filming was completed.

According to a story by Mark Bowden in the *Philadelphia Inquirer*'s Sunday magazine, the city's Commerce Department director, Dick Doran, liked the idea and wrote to F. Eugene Dixon, Jr., president of the Philadelphia Art Commission, which has the final word on placement of art on public property in the city. "I hope we can count on the approval

and support of the Art Commission for this proposed venture," Doran wrote.

Dixon responded that he was delighted about the movie. But in regard to the statue, he wrote: "[I]f the planning for this film includes a statue of Sylvester Stallone to be erected somewhere in the courtyard of the Philadelphia Museum of Art on a temporary basis, that is one thing. If, however, this statue is to be placed somewhere in the courtyard on a permanent basis—I hope you are jesting!"

Thus developed a split in public opinion in Philadelphia. The museum and the arts community rejected the idea, which resulted in petition drives initiated by ardent *Rocky* fans, and backed by City Council members. Supporters felt the museum was being haughty, elitist. Defenders felt that a movie prop didn't belong in front of a world-class art museum.

Sandra Horrocks, who was in charge of public relations and communications at the art museum for thirty years, remembers this saga all too well. She recalls the day that she and the museum's then-director, Jean Sutherland Boggs, met at the top of the steps with Sylvester Stallone as he presented the initial idea of placing a statue at the steps for the movie. It was a surprisingly cold day.

"Mr. Stallone had on this gorgeous leather coat, and he took it off and put it on Ms. Boggs's shoulders. That was very sweet," Horrocks recalled, adding: "There [was] a clear understanding that the statue was temporary, only a prop, and when the filming was over, it would be removed."

When the arts commission rejected keeping the statue at the museum, Stallone arranged for it to be trucked to Los Angeles. Eventually, a compromise was reached: The statue would return to the steps for one month, in the summer of 1982, in honor of the film's opening, and then be placed permanently in front of the Spectrum arena in South Philadelphia, where local sports teams played, professional boxing matches were held, and

the fictional fight between Rocky Balboa and Apollo Creed had been set in the original *Rocky*.

But the agreed upon month came and went, and the statue remained at the steps. It became clear that if it was going to be moved, the museum would have to foot the bill, to the tune of fifteen thousand dollars. When the day finally came, the statue wouldn't budge. "When the men came to move it, they were astonished because they had put steel rods in the terrace—an indication the movie people had every intention of leaving it there. The rods went a number of feet into the terrace. It was clear that they left town and left it there permanently," said Horrocks.

The statue was eventually moved in August of 1982 and has remained in front of the Spectrum ever since—though it returned to the Rocky Steps briefly in 1990 for the filming of *Rocky V*. Quite a few people who come to run the steps also visit South Philadelphia to see and pose with the Rocky statue.

A couple of years after the controversy was settled, local officials agreed that Rocky's footprints—bronzed imprints of his Converse sneakers—be placed at the top of the steps. "That was a perfect solution," said Horrocks. But Philadelphia continues to wrestle with the issue. City officials recently recommended bringing the statue back to the museum and placing it near the bottom of the steps, in a grassy area off to the side.

My year at the steps has led me to conclude that the statue does not belong at the top. The people themselves are the best monument. They serve as living statues every hour, every day.

I approached every day at the steps with exhilaration: Who would I meet? Where would they be from? What would their stories be? I loved watching them all, meeting some of them, and sharing their lives. Like Rocky, I was on a journey of my own.

Tom Gralish and I started on New Year's Day 2004, and we wrapped up the following New Year's Eve. Our method was simple. Tom and I would just show up at the steps. We looked like tourists—a camera around Tom's neck, a notebook in my pocket. We'd observe the steady stream of people as they approached the steps from both the top and bottom, and we quickly developed an ability to tell who was going to run the steps like Rocky. We'd position ourselves as best we could—the closer we got, the more intimate and better the photograph.

We'd watch and listen and take photos as they ran, and only when they were finished celebrating, when their mission was accomplished, would I approach them and introduce myself. I'd tell them I was a staff writer with the *Philadelphia Inquirer*, but that I was working on a book—about people just like them, who still come and run the Rocky Steps. Usually that was enough. They would give me the widest, broadest grins. Many simply couldn't believe it. Some would gladly have spent hours talking to me (and a few of them did). Others had to rush away—a cab or a parent was waiting, or a car was illegally parked. I would give them my business card, get their email address, and continue the interview in the days or weeks that followed, often when they had returned to another continent. Usually I had a tape recorder in my hand at the steps, because many times the exchanges were quick, and the runners would speak, often gush, faster than I could write. I didn't want to miss a word.

There were some days I went without Tom, who couldn't be there as often as I could. I learned to take my own pictures, several of which made it into this book, but I am no Tom Gralish. He has a creativity, a warmth, and a sense of humor that clearly emerge in his photographs. He was a great partner.

Tom and I were not always successful. There were several Rocky runners who simply got away. The most frustrating failure was a young Australian from an Ivy League college, a member of its crew team. He was spending the summer rowing on the Schuylkill River, and one afternoon decided he needed to run the Rocky Steps, but in his own unique way: naked.

As I often did, I rode my bicycle that day from the *Inquirer* office to the museum, and as I pedaled up the Parkway, I saw him drop his drawers and take off up the steps. I couldn't park my bike and get my camera out in time, but I saw him sprint to the top. Patrice Pittman, who drives a trolley with Philadelphia Trolley Works, was sitting at the bottom of the steps, reading a book. She had delivered a wedding party who were at the top of the steps posing for pictures. She thought to herself, "Oh, my God! There's a wedding party up there. Oh, he can't be…"

I saw the wedding party point and stare as "he" ascended. One of the bridesmaids told me later what she remembered most was a tattoo on his rear end. At the top, he danced and celebrated, then ducked into a waiting getaway car—and he was gone. His friends who filmed his ascent, and who were still there, told me he was a rower, but that was all. I called my contact along Boathouse Row—a two-time East German gold medalist, now living and teaching in Philadelphia—and she tracked down my naked quarry. He refused to let me use his name and image. I did, at least, find out why he ran: His roommate, he said, was so timid, always worried about what others thought of him; he was afraid to be bold. My naked Australian Rocky runner wanted to do something audacious, to prove a point, to show the roommate that being bold can be fun. I still cry over losing that one.

I also couldn't convince another man, a Canadian, to share his story in detail. The man's father had left him and his mother when he was a small boy. After a decade of not seeing his father, the teen flew to London for a reunion. The father picked him up at Heathrow Airport and the

first thing they did—honest—was to go and see *Rocky* together. This was almost thirty years ago, and the movie had just been released. The man cried at the top of the Rocky Steps when he shared the story with me. But he didn't want to elaborate. I guess the pain was too deep.

John Kerry also broke my heart. In July, a few days before the Democratic National Convention, he held a huge rally on the plaza at the top of the museum steps. I called his campaign people and asked if he would be running the steps. They didn't think so. They were right, but from a huge stage erected on the plaza, Kerry did at least make reference to Rocky: "I may not have run up the steps," he said, "but I'm going to deliver the knockout punch." I'm no expert, but I am confident that if John Kerry had run the Rocky Steps that day he would have won the election. Fancy suit, security details, and campaign cosmetics all be damned. A man with real heart—who felt the *Rocky* passion, who was willing to go the distance—would have run the steps.

Tom and I were at the steps on Easter Sunday at dawn. We were there on Mother's Day and the Fourth of July. We were there at midnight, at lunch hour, on weekends, and on Halloween night. We were there in snow and rain and cold and heat. We'd often hang around for a couple hours at a time. That was usually more than enough. Too much longer and we wouldn't have been able to keep everyone straight. The best days, the busiest days, were the sun-dappled weekend afternoons in spring and fall.

I brought my parents to the steps in June, just three weeks before my father died of leukemia. They had come to town for my daughter's high-school graduation. My father had such a spirit, such a will to live. He and my mother had heard me talk so much about the book I was writing that they wanted to see where I spent my time, see how I did my work. My father was too sick to run the steps, too sick even to walk them. We parked near the top, and strolled to the steps. The image is sharp in my mind, and it saddens me that I didn't think to take their picture there. I hadn't even brought the camera. We remained at the top for a while, watched the people, talked to a few runners. They understood what I was trying to do. My father's journey through life, and in particular his courage and endurance at the end of his life, his love of life, can only be described as Rocky-like.

All the people you'll meet in this book have one thing in common: they came to the museum steps and celebrated like Rocky. But their stories, their lives, are as rich and varied as America itself. The dream is universal—overcoming, achieving, rejoicing—but the variations are infinite. For at least a moment, the problems of the world—war, hatred, strife, setback—fade away. Running these steps represents a triumph of the individual, a celebration of hope and accomplishment. That's the abiding joy of the Rocky Steps. ★

WINTER

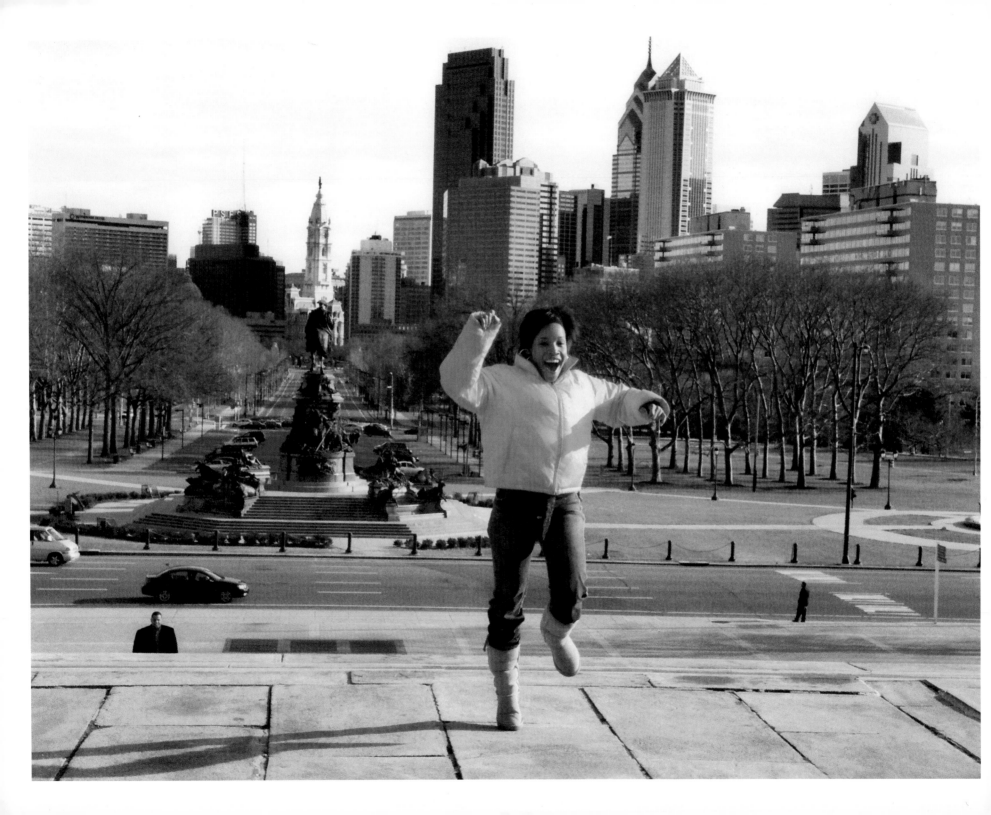

1 FIRST AT THE TOP

★ LeShay Tomlinson was the first runner we met. She ran on our first day, New Year's Day. She was so excited to be there, more excited and moved than she had anticipated. These steps provided a milestone of sorts, a symbolic way to rededicate herself. – M.V.

On January 1, a sunny, cold, invigorating introduction to the new year, LeShay Tomlinson arrived in Philadelphia. LeShay, an actress, had flown from Los Angeles to New York and taken the train to Philly. Her boyfriend, Maurice Smith, a fellow actor she met on the set of a sitcom, greeted her at the station in Philadelphia. He was a Philly guy, back home for the holidays, and she had come to meet his family.

Their first stop was not his house, but the steps of the Philadelphia Museum of Art.

Maurice parked at the bottom of the steps (illegally, as so many do), and LeShay, twenty-eight years old, bounded out of the car and started running. This kind of thing is common among Rocky runners. The steps seem to beckon. As she started, LeShay raised her hands over her head, in anticipation of victory, unable to contain her zeal. She was a sight to behold in fur-lined suede boots, a bright yellow coat, and hoop earrings. Her smile was as radiant as the blue afternoon sky.

The steps were crowded; they often are. Another woman—a phantom in a full-length overcoat—decided to race against LeShay. This was rare. Most runners enjoy the solitude of the *Rocky* moment, and they allow each other to enjoy the ritual without competition.

Onlookers quickly realized a race was afoot and began to cheer. Maurice, out of the car now, was taking pictures. In his youth, he had run these steps many times. Even now, though he lives in Los Angeles, his cell phone rings with the *Rocky* theme song.

LeShay had never been a particular fan of *Rocky*, but she had a dream of her own, and dreamers often come seeking inspiration. For LeShay, running the steps was a symbolic gesture—a new year, a new beginning. Only weeks before, she had flown first-class to the Bahamas to play the part of a receptionist in a feature film, *After the Sunset*. She even had a few lines. This was her time; she could feel it. She was ready to break out.

As LeShay reached the top, having climbed all seventy-two steps (and having defeated her rival), she spun, just as Rocky does, to face the city below. She thrust her hands high, "rockying" in celebration. Maurice caught it all on film—even the part where LeShay doubled over, grabbed her knees, and gasped for breath. "Man, I'm tired." She was still radiant and smiling, but she is, after all, an actress, not an athlete.

"I wanted to do it just like the movie *Rocky*," she panted. Maurice gave her a hug.

"I heard the music in my head," she said.

"You're flying high now," he said.

"This is the first place in Philly I wanted to come," LeShay told me. "The bags are still in the car. I just decided this year to be more aggressive and go places in my acting I haven't tried before. That was all tied into my New Year's resolution. I'm going to go to Philly and visit the Rocky Steps. This whole racing thing, I didn't even plan it, but that's how I always imagined it—getting ahead of everybody, being first at the top."

RUNNING THE STEPS WAS A SYMBOLIC GESTURE—A NEW YEAR, A NEW BEGINNING.

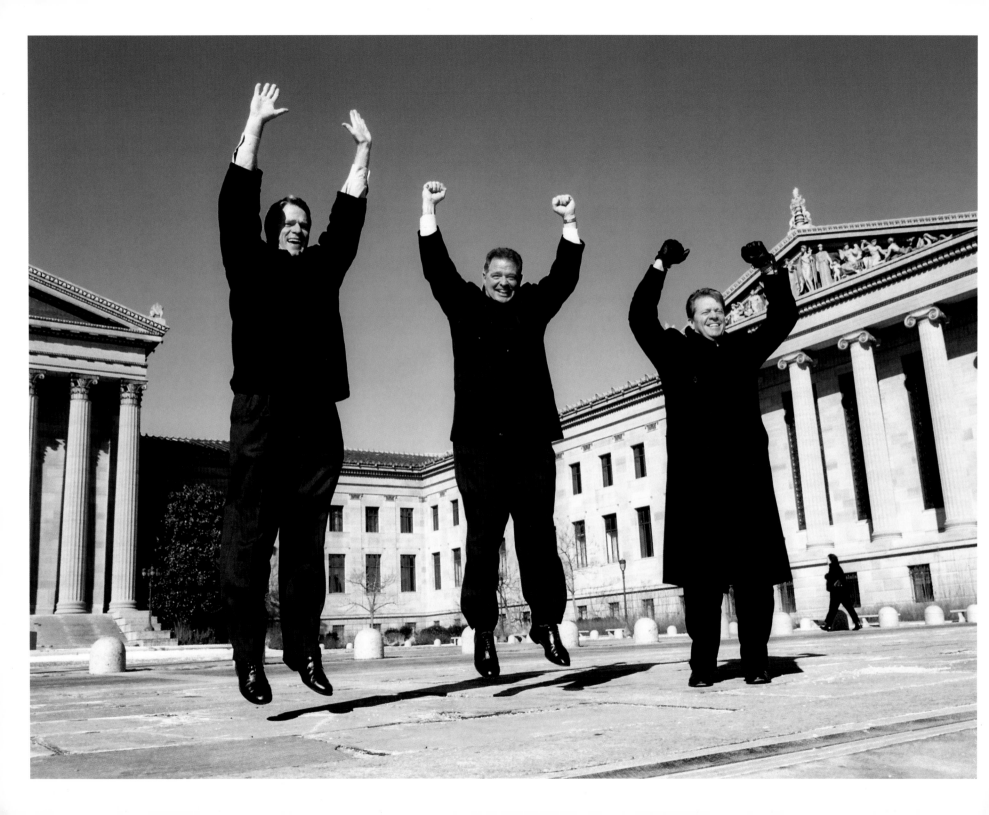

2 MEN IN SUITS

★ These guys were the ones who really convinced us we had a book. If a trio of businessmen in expensive suits would run the Rocky Steps in the dead of winter, then I knew there was still magic here. Tom and I were hanging there on a cold January day, just waiting, hoping. When they started running, I felt warm inside.

Dan Checketts, of Bountiful, Utah, shared a dream: to launch a regional college sports television network out West. He came to Philadelphia with his brother and a third business partner for a meeting with Comcast, the media giant.

When Dan kissed his wife goodbye the day before, she told him: "Make sure you run the Rocky Steps!" Dan explained, "She thought that it truly would put all of us in the right frame of mind. She wanted us to enjoy the feeling of being at the top."

Dan, forty-five years old, was the junior member of this trio, the least experienced in such important meetings. His older brother, Dave, had been president of the New York Knicks basketball team and CEO of Madison Square Garden. Dean Howes, the third member, also had experience with

big business deals. Dan had flown to New York to meet the others. As they drove down the New Jersey Turnpike, Dan was itching to run the steps as his wife had urged, but he felt he couldn't suggest it before such a pivotal meeting. The others, he feared, might think he was being silly, so he kept silent. "I wasn't going to force the issue."

Then an amazing thing happened—Dave brought it up. "Let's run the Rocky Steps," he said. Dave Checketts had his reasons: "I was twenty when *Rocky* was released, saw it with my older brother and father. Both are gone now. 'Aspirational' is the word I'd use to describe the movie, the story. It is what we all aspire to, to get a shot at it."

It was just after noon on Wednesday,

"SHE WANTED US TO ENJOY THE FEELING OF BEING AT THE TOP."

January 21, sunny and twenty-three degrees. The three men had a couple hours before their meeting. They parked on Kelly Drive just behind the art museum and got out of the car. When they turned the corner, they saw the steps before them. In suits, button-down shirts, black dress shoes, and wool overcoats, they started running. "The suits did not slow us from running the stairs," Dan assured me. "We would have run those stairs in our pajamas."

They ran three abreast. Not a sprint, but a jog. They were sheepish at first, self-conscious. But as they climbed, they began smiling, laughing, loving the moment. They were kids again. When they reached the top, they turned around, but were reluctant to leap up in the air, to thrust their fists upward in victory as Rocky does. But there was no denying the

populist trot they had just taken; they felt the bond.

They looked around for the Rocky statue. Like so many runners, they expected to see it there at the top. They asked a museum guard and learned the statue was now at the sports complex in South Philadelphia. They did find Rocky's sneaker imprints at the top of the steps, and only then, warmed to the idea, all inhibitions gone, did they perform the requisite and liberating leaps.

Adequately pumped up, the trio proceeded to their meeting. "It went great," Dan later reported.

After the meeting, he called his wife, Ginny. "I hate to say this," he said to me, "but I told my wife about the meeting first. It was a very important meeting. But being totally honest here—I couldn't wait to tell her about the steps."

3 THE SNOWMAN

★ His story is a classic Philadelphia chronicle of a different sort than *Rocky*—a man from the poorest of neighborhoods who hits rock bottom and stays there. Here on the steps, Spencer Rogers was on the rebound, and I found myself rooting for this man. For him, life will be an uphill climb every day, but he's trying. I hope he makes it.

Spencer Rogers has lived a very tired, all-too-common American urban story. As a teenager, he dropped out of high school, became addicted to crack cocaine, and spent more than twenty years living in abandoned houses, begging for money on the streets—always using that money for drugs. He had no real job and no sense of self-worth.

Spencer grew up in North Philadelphia, not far from the Philadelphia Museum of Art. He'll tell you: His mother didn't fail him; he failed himself. His mother taught him manners. She taught him right from wrong. All his life, he knew he was doing wrong. He just gave in to temptation. As a grown man, he would come to the Rocky Steps and panhandle from tourists. Rocky Balboa brought the tourists here, and Spencer hustled them for a dollar.

His life changed at age forty-three. He was in the habit of hanging around a self-serve gas station, offering to pump gas

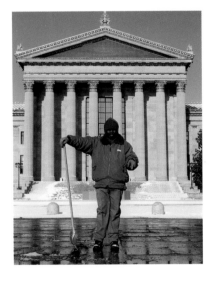

for people who pulled in, hoping they would tip him a dollar or two. That was his life: all night in an abandoned building, cold winter days doing this. One day a man pulled in for gas. He bought Spencer something to eat. He told Spencer he didn't need to live the way he was living, and gave him his business card. That man, Richard Chandler, ran a program for recovering addicts called

Ready, Willing and Able. Spencer would have to go into detox first, get clean. He'd have to decide he wanted a better life. But if Spencer did that, then Richard Chandler would help.

Spencer kept Chandler's card. About two months later, "it was so cold, that as I was crying, the tears was ice," he recalled. "When I got to that gas station, I said to myself, 'I can't do this no more.' I asked God to help me. 'I can't do this no more.' In the next twenty minutes, I made $1.25. I used 75 cents for a cup of coffee, and 50 cents to call Richard Chandler."

Spencer spent a month in detox. Then he moved to a group home run by Ready, Willing and Able. The program strives to give recovering addicts dignity and self-worth. They receive intense counseling and support. Best of all, they work and they get paid for it.

The men from Ready, Willing and Able sweep the steps of the art museum three times a week. When

it snows, they shovel the steps. Spencer had been drug-free for five months when he shoveled the steps on a snowy, fourteen-degree day in January. After he shoveled a path, he ran right up those steps, like Rocky Balboa, carrying his snow shovel with him, and celebrated at the top. And in a sense, he *was* Rocky, an underdog if ever there was one, fighting the fight of his life—and winning. If he and others in the program could stay clean, earn some money and some confidence, they had a shot at turning their lives around.

"I lived with addiction for twenty-five years," said Spencer. "And to get up every morning and do what's right, for the right reasons, it gives you a feeling, I can't explain it. You feel good on the inside."

IN A SENSE HE WAS ROCKY,... FIGHTING THE FIGHT OF HIS LIFE.

4 VALENTINE

★ We were tipped off that something wonderful might happen at the Rocky Steps, and since it was Valentine's Eve, Tom and I waited around in the freezing cold. Finally, we saw the horse and carriage approaching. I tried to keep my distance. I didn't want to intrude on the moment. But I also wanted to be close enough to describe what happened. I do love a love story.

Michael Sessions, twenty-five years old and from Austin, Texas, is in the United States Air Force and flies on jets to Iraq. He's flown there fifteen times, as a staff sergeant and mechanic's mate on giant C-5 transport planes. He is stationed at Dover Air Force Base in Delaware.

On a weekend leave in 2003, just as the war was about to begin, Michael went to Cherry Hill, New Jersey, just across the Delaware River from Philadelphia, for a going away party for one of his close friends and crewmates, who was being transferred to Korea. The party was at a local night club.

Denise Stout, who was at the club with a friend, spied Michael at the bar. Even with his Air Force-regulation shaved head, "He was really cute," recalled Denise (who is twenty-two and runs catering sales for a local hotel),

"but he was acting all cool." She asked him to dance—not once, not twice, but three times before he finally agreed. That's when he figured out what a good thing he had going. They danced together for five songs in a row, beginning with Van Morrison's "Brown Eyed Girl." "From that very first dance," he recalled, "I fell in love."

When the club closed, they didn't say goodnight. Instead, they went to an all-night diner for coffee. Finally, at three o'clock in the morning, Michael called a cab for Denise. He waited with Denise, saw her into the taxi, and started to walk away. Suddenly, he turned, sprinted back, threw open the door, and kissed her. "In case we never see each other again," he said, "thanks for a wonderful evening."

An hour later, Michael called Denise on her cell phone. He called her nearly every day for a year,

and visited every chance he could. He called her every time before he flew to Iraq, just to hear her voice. As the months passed, he knew he wanted to marry her. "My biggest fear," he recalled, "was with everything the way it is, and people getting killed over there, if I never did come back home, I just never wanted her to have any doubt in her mind at all that she was the only one for me."

In January, Michael decided to propose to Denise, and he knew just where he wanted to do it: at the steps of the Philadelphia Museum of Art. "I knew from the movie *Rocky*, I knew where I wanted to go," he said. "It's beautiful and romantic and overlooks the city."

On Valentine's Eve, he arrived at her

MICHAEL DECIDED TO PROPOSE TO DENISE, AND HE KNEW JUST WHERE HE WANTED TO DO IT.

home, blindfolded her, and drove her to the Ritz-Carlton Hotel. Around nine o'clock, after an elegant dinner, a white horse and carriage were waiting for them. On that cold, clear, starry night, Michael and Denise snuggled under a blanket for a romantic ride through the city, serenaded by hoof beats, past Independence Hall and the Liberty Bell, to the Rocky Steps.

Michael got down on one knee:
It hurts me every time we're apart.
I love you with all my heart.
I want to be with you for the rest of my life—
Only if you'll be my wife.

From his pocket he pulled a diamond ring and slipped it on her finger. Denise cried. They kissed, and kissed again. They promised each other they would come back, when the weather was warmer, to run up the steps like Rocky.

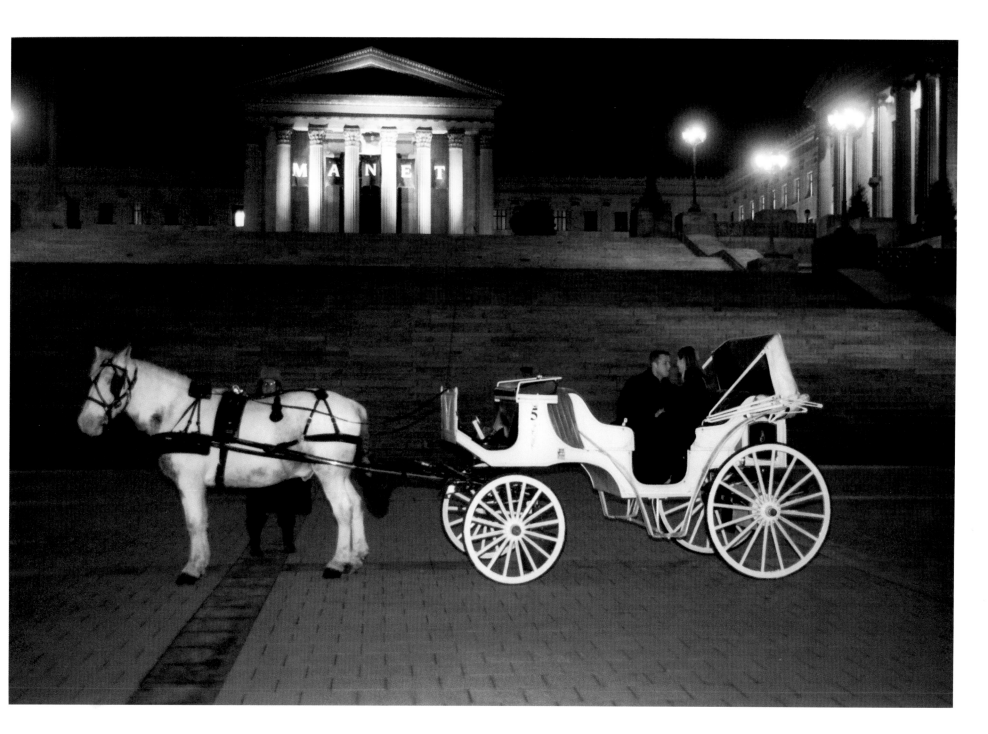

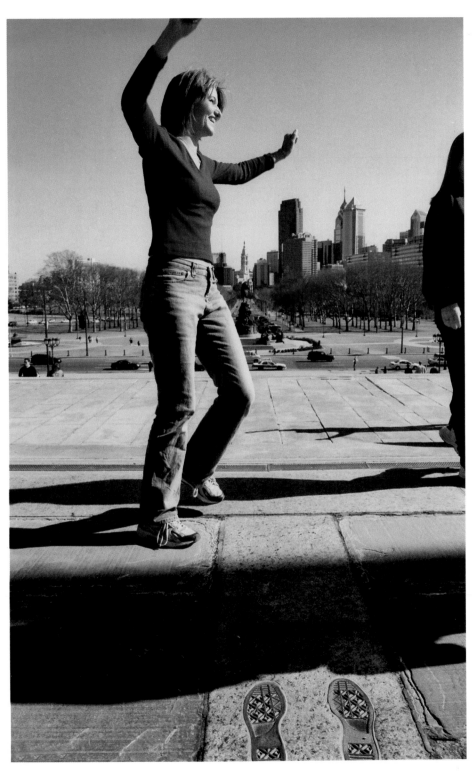

5 THE MISSIONARIES

★ David Hain followed his heart and his faith, which has led him to a life of fulfillment, albeit one that isn't always easy. He was like the fictional Rocky in this way—he has guts, and a love for the City of Brotherly Love.

David Hain woke up in the middle of the night in a hotel room somewhere in Europe. He used to travel so much for his corporate job that he literally did not know where he was. He fumbled for the light switch and couldn't find it. He felt an emptiness, a pointlessness, and a call to change—to devote himself to God and to others. He flew home to Wilmington, Delaware (he'd been in Frankfurt, Germany), gave two weeks notice at his office, and became a missionary.

He started out offering food to homeless people who slept on steam grates in Philadelphia, but he also traveled the world in pursuit of his new calling. After a couple years, he met Shawn—also a missionary—and they married and settled in a very poor and beleaguered neighborhood of Philadelphia where they ran a mission for heroin and crack addicts.

They owned nothing. "Literally, at one time we were down to less than a dollar in the world." But, David told me, they had their faith. "If you don't put yourself in a position to need a miracle," he said, "you won't notice one when it happens." People they barely knew donated money to keep the mission going. David said it has

been the most joyous time of his life. "All my working life, I had always given of myself in expectation of getting something in return—power, prestige, a promotion. There is a real joy in giving of yourself and expecting nothing in return. And when something wonderful does happen—you help a girl out of prostitution or an addict out of addiction—the joy you feel is almost indescribable."

His organization, Adventures in Missions, soon asked him to supervise week-long trips to the inner city by groups of high-school and college kids from around the country, usually from rural and suburban areas. The students know nothing of cities. Their parents call David and "ask me to promise their children won't get killed." David wants these young people to love Philadelphia as he does, to get comfortable in it, to become ambassadors for the city when they return home.

He took his first group to the famous historic sites. "I found very quickly that the Liberty Bell and Betsy Ross House didn't do it. They took pictures, but there was no excitement. So I mentioned *Rocky*, and everybody's

"I MENTIONED ROCKY, AND EVERYBODY'S EARS PERKED UP. THEY'D ALL SEEN ROCKY."

ears perked up. They'd all seen *Rocky*." He used the movie as his ambassador.

The poor neighborhoods where he did his missionary work were the same neighborhoods where *Rocky* was filmed. "Did you realize it was all filmed right here?" he asked them. "You're right here under the el, where he was. Up this street is what they used for Adrian's house. Right over here is the pet store where Adrian worked. And here's the building they used for the gym." Everybody got excited. The climax of the week, of course, was a trip to the Philadelphia Museum of Art, during which everybody would run the steps and celebrate at the top.

David and Shawn have done this now with hundreds of groups. One of David's missionary colleagues even expanded on the idea. She now brings her groups to the Rocky Steps for a run, and then a two-hour session of prayer and reflection at the top.

David has continued to travel the world as a missionary, and always invites the people he meets to visit him in Philadelphia. When they do, the first place he and Shawn take them is the Rocky Steps.

6 THE PILGRIM

★ The steps and the movie and what Rocky represented may have meant more to Mehdi Jabrane, may have affected him more, than anyone else I met there. I will long remember his smile, his zeal, his desire to walk a righteous and successful path.

Mehdi Jabrane, twenty-five years old, is the son of a Moroccan father and a French mother who met working in a shoe factory in Pau, a small city in southwestern France. Mehdi grew up there, in a housing project for immigrant workers. He had a very difficult childhood.

"When I was with white kids they treated me like an Arab. When I was with Arabs, they treated me like a white." He was raised as neither Muslim nor Catholic, but simply to believe in God. It seemed everybody else in school had more money than his family, who couldn't even afford a car. "I always felt I was inferior," he said.

His father had a drinking problem, and when Mehdi was sixteen, his parents divorced. He began to get into trouble as a teenager and dropped out of high school in his last year.

Mehdi first saw *Rocky* on television when he was young. "I was shocked," Mehdi recalled, "because a guy from nowhere made an incredible thing, becoming the world champion, a thing he never dreamed because it was so far from his reality."

Rocky Balboa became his role model. "Because I never used to talk with my father," he explained, "I always tried unconsciously to find a paternal figure. I don't know how many times I saw the film on TV, on VCR, and now on DVD, but it always makes me cry when I'm alone. It gives me

hope. It gives me courage. When I see the film, I still do pushups with one hand. Thanks to those films, I always knew that I have to stay positive, even if sometimes I wasn't that good."

In 1998, an American vacationing in France invited Mehdi to visit her in Philadelphia. He mopped floors for four months to earn airfare, but the day before he was to leave, she changed her mind and told him not to come. He went anyway. "I decided to go to Philly to make my dreams come true," he said. He ran the Rocky Steps like his fictional hero. "When I was there, I can't describe the feeling I got. It was like a new start."

Back home, Mehdi began to turn his life around. He entered a work-study program at a pharmaceutical firm, and soon he will receive his college degree, the first in his family. He has plans for an MBA. "I know it will be difficult, but I

know everything is possible."

He has returned to Philadelphia twice to run the steps again. "It's like a pilgrimage," he said. "I find my motivation in Rocky, maybe because he's a model for me. He's humble, modest, a hard worker, and he never gives up—all the things I really want to be."

I met Mehdi when he visited the museum steps on February 28, a Sunday, about two o'clock. He came with friend Kevin Sampson. They ran together, laughing. At the top, both faced the city and raised their arms in victory. Then they hugged. Sampson's girlfriend captured it on video.

"Each time, it's the same motivation, the same desire, the same dream," said Mehdi. "When I'm upstairs, I feel great, untouchable, proud, because the road was long for me to come here. I'm not talking about the trip from France, but the road to be a good person."

7 DOUGHNUTS

★ These guys were not awed by *Rocky*. To them, the movie was a cornball piece of Americana. At first I was concerned—wasn't this anti-*Rocky*? But they took the *Rocky* story and reinvented it, composed their own variation on the theme. These young Drexel students may have had the keenest insight of all about why people run the Rocky Steps.

The assignment from Professor Chris Redmann to his class at Philadelphia's Drexel University was straightforward. "Go out and wreak havoc on our fair city." Redmann teaches digital media to aspiring movie-makers. The students were to shoot live video on a sunny day and then manipulate the video to create a disaster on their computer screens.

Students broke into groups and chose a variety of mayhem—swarms of locusts, meteors, tornados, a flood, even the apocalypse—to ravage Philadelphia. One group conceived a deliciously unique menace: three giant doughnuts mauling a tourist as he runs, *a la* Rocky Balboa, up the steps at the Philadelphia Museum of Art.

J Goldberg—whose first name is simply J—has a pierced nose and wore a black t-shirt that read "Poison." He dreamed up the idea of doughnuts assaulting a Rocky runner. He and the others in his group agreed it was a perfect idea because every time they go to the steps—Drexel is just a mile from the art museum—they see the masses running up, pretending to be Rocky. "There's always somebody doing it," said J.

On the day they went to stage their own *Rocky* footage, they had to wait half an hour to find a moment when nobody was running up the steps for real.

For the record, the students in J's group don't think *Rocky* is credible or realistic. "It was a big movie for our parents," said Dave Bartos. "But it wasn't that significant a movie in my life. I was more into the Mutant Ninja Turtles."

Nevertheless, each of the four in the group had run the Rocky Steps when he arrived at Drexel, and when friends visit from out of town, they all want to run, too. J has a theory about this, and how the world is changing.

"You can't do what the actors do in *The Matrix*," said J. "But you can do what they do in *Rocky*. You can run up the steps. You can pretend you're Rocky for a split second. In movies where compositing is king, you can't do this, and 85 percent of movies today have digital elements or compositing."

Back in class, their video was a hit. The class saw a father filming his son running the steps. When the son, dressed in a Rocky sweatsuit, reaches the top, he circles and raises his arms in triumph. Then he looks to his right in horror and sprints to his left in panic. He is pursued by a ten-foot-tall powdered doughnut, followed by one just as big with chocolate icing, and finally, a gigantic glazed one. The scene was inspired in part, said the creators, by the children's book *Cloudy with a Chance of Meatballs*.

Chris Redmann loved the presentation. Much of his critique was in tech-speak—"really good integration...the alpha channel ended up blurring...nice rotoscoping"—and one bit of wisdom even a visitor to the classroom could appreciate: "The lighting on the doughnuts may be a bit harsh."

"YOU CAN PRE-TEND YOU'RE ROCKY FOR A SPLIT SECOND."

8 FATHER DOES BEST

★ Latone Allen's dedication to his children radiates, just like the steam off his head on that cold, pre-dawn winter morning, an image that will stay with me for a long time.

Latone Allen uses the Rocky Steps every day as a metaphor for his life. If he can climb the steps ten times, at 5:30 A.M., he will be able to overcome any challenge.

"It starts out here," he said one freezing morning before dawn. "If I can get up at 5 A.M. and run ten flights here, I can do anything." He wants to provide for his two young sons, to give them a better foothold in life than he had himself.

"My dream is to see my kids have a better life than I have, with less struggle. The stairs help me do that. In my job [as a loan officer for a mortgage company], if I feel good, then I produce better, I perform better, I can do better for my kids. So I come here for me and my family."

Latone, thirty-two years old, is from Chicago. The Navy brought him to Philadelphia to work in its shipyard. He and his wife met here and had two sons here, but they divorced in 1999. He moved back to Chicago, but couldn't live with himself.

"My father wasn't in my life a lot," he explained, "so I moved back here to be with my kids, to be a parent, to live up to my responsibilities. That's the role God laid out for me, to provide for my kids. I couldn't sleep at night. I had to be here."

His ex-wife, Jamila Hankinson, introduced Latone to the Rocky Steps in a happier time. "I used to run a lot of steps, usually at a high school," he said. "My wife brought me here and said, 'You'll like these better. These are the steps Rocky ran.'"

Jamila actually ran these steps in *Rocky II*. Students from her elementary school in South Philadelphia were recruited to chase the now-world famous Rocky Balboa through the streets, wild with adulation. "We kept catching him," Jamila recalled.

"I COME HERE FOR ME AND MY FAMILY."

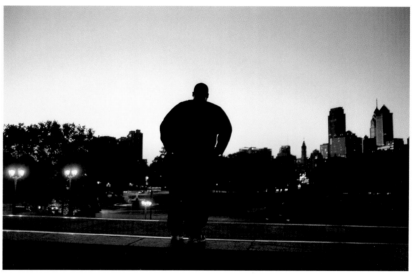

"I guess he was out of shape. They started us so far back, and kept telling us, 'Don't pass Rocky. Don't pass Rocky.' We had to do it over so much because we kept catching Rocky."

Jamila is no longer close to her ex-husband. In real life, not every relationship can be Rocky and Adrian. But of Latone, she says, "He's a great dad."

Latone loves the steps. He feels like a winner when he runs here. He loves the landings between flights. "They give you time to regroup, catch your breath a little, and hit the stairs again."

He is a freight train, choo-choo-ing, wheezing, lumbering, groaning as he powers up the seventy-two steps, usually two at a time. By the fifth trip, he doubles over in pain at the top. He turns, raises his hands in victory, and then descends, doubling over again at the bottom. But he turns and does it again. The theme song to *Rocky* often plays in his head. In almost any weather, he bundles up in a hooded sweatshirt, the better to sweat.

After he's done, he goes to a gym to lift weights for an hour, then off to work. "It's a good business," he said. "You can affect people's lives if you're honest."

9 COACH

★ Joshua Appleby had no idea of the impact running the steps would have on him. Doing so helped him to put his own life in perspective and to realize what he loved most—coaching football. Even I was amazed how much this jog meant to him.

Joshua Appleby, a Texas middle-school teacher and football coach, was at a crossroads in his life, so he came to the Rocky Steps—to run, to help himself find the answer.

"I want more time to travel," he said, "but I enjoy coaching. You know Texas. Football is everything, is God. I just don't know what I want to do."

Joshua, twenty-seven years old, grew up in Alabama. He started playing football at four. As a boy, he was always big, and he always had to lose weight to be eligible for his age group's weight class. So he was always dieting. In high school, coaches wanted to make him a lineman, but he loved playing running back. He had to work extra hard—situps, pushups, extra windsprints—to stay lean and quick.

"I remember when I would work out, my motivation was Rocky and his story," Josh recalled. "Even when I felt like not working, I would remember the quote from Apollo Creed, 'There is no tomorrow!' And I remember how I would get motivated from watching Rocky run up those steps. Each step Rocky took was like another step toward success."

Josh worked hard to get where he is today, teaching and coaching in San Antonio. He was the first member of his family to go to college. He paid his own way. "I worked as a stocker in a grocery store from 11 P.M. to 7 A.M.," he said. "Then I would go to class." He now has his master's degree.

He and Janelle Vollmer, his fiancée, who is a special-education teacher at his school in San Antonio, both love to travel. They vacationed in Philadelphia on spring break in March. A big reason for coming was to run the Rocky Steps, something Josh has always wanted to do, something he needed to do, more than he even knew.

On the tour bus to the museum, he was singing the movie's theme song. The bus driver put the microphone in front of him, but he clammed up. He couldn't bring himself to sing to everyone. As he stepped off the bus, he took in the vista he'd seen scores of times in the *Rocky* movies. Then he made sure Janelle had the camera ready, and he started running. Knees pumping like pistons, he said to himself, "Got to do it."

When he reached the top, he was winded, but he had a broad smile on his face. "It was just something that I've always wanted to do," he said. He lingered at the top, enjoying the moment.

Josh and Janelle went on to Atlantic City for a couple days of gambling before they returned to Texas. Two weeks later, Josh sent this email:

"I do not think I will give up coaching. I love ending my day with great students that are

"I REMEMBER HOW I WOULD GET MOTIVATED FROM WATCHING ROCKY RUN UP THOSE STEPS."

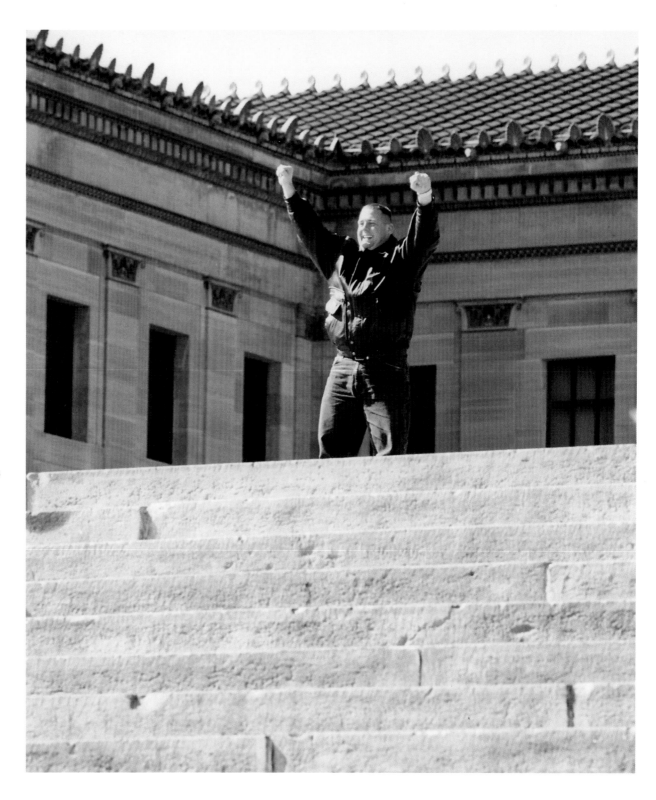

trying to better themselves. Running those steps made me think how important sports are to me in my life. I would have an empty feeling in life without direct contact with sports.

"On another note, I have been wanting to get back in shape for years, the way I was in high school when we won back-to-back championships. Running the steps kind of gave me the motivation to quit feeling sorry for myself and *do it*. I decided to take the old phrase from Apollo: 'There is no tomorrow!' I'm dieting and working out. On our next trip to Philly, I will run up the steps without breathing heavy."

10 VEGAS SHOWGIRLS

★ These dancers were so enthusiastic, so determined to run the steps. They were among the first people I met who used the Rocky Steps as a moment to celebrate their own accomplishments in life.

When Kristine Keppel was ten, in 1961, she saw *West Side Story* for forty cents at the Beach movie theater in the Bronx. "After seeing Jerome Robbins's choreography and listening to Leonard Bernstein's score, something inside me clicked," she said. "That's when I knew I had to dance!"

But she didn't have a clue how to begin, and neither did her parents. It wasn't until years later, at Jersey City College, that "I began to understand that if I wanted to know how to dance, I had to study it." So she took every dance class she could. She studied ballet at Carnegie Hall—she was a twenty-year-old in a class of ten-year-olds. "It's too bad you didn't start when you were young," her teacher told her. "You have a great dancer's body."

Kristine took jobs wherever she could find them, even in Europe.

"It was difficult for me, because I wasn't used to picking up the steps fast. But with perseverance, I found more dance work."

In 1981, she got a big break, landing a job in Las Vegas as a "Copa Girl," a member of the elite chorus line. She danced in Vegas for a decade, a life of feathers and sequins and false eyelashes—for her, a dream come true.

In 1990, nearing forty, she gave up dancing for a job teaching English in a Las Vegas high school. In 1993, a performing arts high school opened in Las Vegas, and she was hired to teach English and dance, though she had never actually taught dance before.

In a crushing blow, the principal dropped her as a dance teacher, so she transferred to an inner city high school and started a dance program

"WHAT I HAVE ACCOMPLISHED IN MY LIFE IS LIKE A ROCKY STORY."

there. Kristine improved greatly as a teacher, and as a motivator and a manager—and her program became a success. The principal of the performing arts high school saw a performance, and invited Kristine back.

In March, Kristine brought her students to Philadelphia for the National Performing Arts High School Dance Festival. During a break, she and a few other teachers were walking past City Hall—a mile down the Benjamin Franklin Parkway from the Philadelphia Museum of Art—and she saw the Rocky Steps.

"We have to run them," Kristine said.

"You're crazy," the others told her. "They're too far away. We don't have time."

"I gotta go," said Kristine.

Kristine and fellow teacher Lisa Lazenby walked to the museum. Memories overwhelmed her. She

remembered when she saw *Rocky* for the first time, in London's Piccadilly Square when she was a struggling dancer, and how she identified with Rocky. As she approached the steps, Bill Conti's music began pounding in her head. Then she began singing it. She felt elated and thought to herself, "What I have accomplished in my life is like a *Rocky* story."

Lisa, also a former dancer, began feeling the same energy and emotion. At the bottom of the steps, both teachers took off running. They flew to the top, effortlessly. They were dancers after all. They turned to face the city below, raising their arms in victory, and loving the moment—performers on stage again.

In Kristine's words, "We did our dreams."

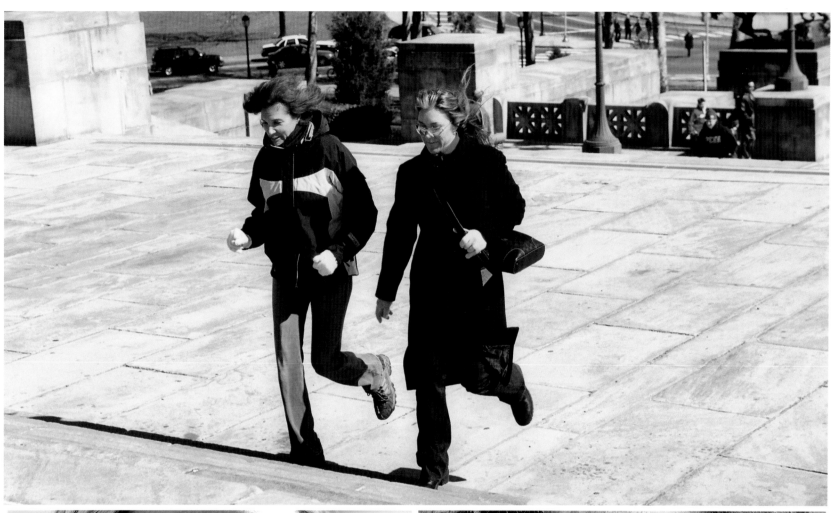

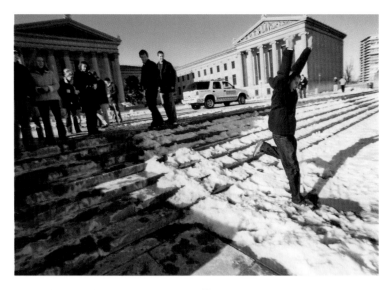

The scenes at the steps of the Philadelphia Museum of Art might never have made it to the screen—and wouldn't have become as memorable—were it not for Garrett Brown and his revolutionary Steadicam.

Brown grew up in the Philadelphia area, the son of an inventor. His dad worked for Dupont Chemical Company (he invented "hot melt," the plastic polymer that replaced the old animal glue in the binding of paperback books), but Garrett did not follow immediately in his father's footsteps. He entered Tufts University on an ROTC scholarship. Soon, however, he decided that his dream was to become a folksinger. There was one problem. "It turns out you can't just walk away. You're an enlisted man for four years," Brown recalled. "But there's a provision that if you flunk everything, they'd decide that you're hopeless and they don't want you. So I called my father and said, 'Look, I'm going to be a singer. I'm going to flunk everything.'"

Brown did flunk out of Tufts in 1962, and for three years he toured as a folksinger with a band. "That crashed to a halt pretty much when the Beatles arrived," he said. "But I didn't have, it turns out, any marketable skills."

He sold Volkswagens for a year, then quit that job to investigate his new passion—filmmaking.

"I read every book on filmmaking in the Philadelphia library, but they were all out of date, of course. So I bought ancient equipment. I literally had an eight-hundred-pound dolly, a rusty old piece of crap, and some rails. And yet my camera was light. It weighed ten pounds."

Brown earned a living making television commercials, but he wanted to direct movies. At that he was less successful. "I starved and failed," he said. But his inventor's instincts began to take over. He dreamed of a camera that was much more portable, affordable, and stable than anything that existed.

"You can't *hold* a camera," he explained. "It looks like hell. I wanted to create something portable but steady. There was nothing like that. Everybody else did it on a dolly with wheels."

Brown tinkered for a year and a half. At one point, he checked into a Holiday Inn in West Chester, Pennsylvania. "I dragged out all the drawings and thought about it for about a week," he said. "I would run up and down the hallway with broomsticks balanced on my fingers, and the maids would laugh. I'd always be out in the hallway running along, looking at what happened to an object that had some length and inertia to it when you didn't influence it with your hand. It was clearly an issue of balance and isolation. How do you get isolated from this thing, so all your moves don't get through to it?"

Brown finally developed a harness to wear on his shoulders from which he could suspend a camera. That allowed him to isolate the camera from his body. The camera went where he went, but remained balanced and stable, cushioned from the vibrations and other unwanted effects of his body's movements. He was thus able to move with, and around, his subject while filming with a fluid intimacy. He completed a final set of drawings and took them to a retired machinist for execution. The Steadicam was born—except that he called it the "Brown Stabilizer" at first.

By this time, Brown was thirty-two years old and nearly broke. He needed to make a demo tape that would show Hollywood what his camera could do. He and Ellen Shire, who would become his wife, were driving past the Philadelphia Museum of Art one day when inspiration struck.

Brown stopped the car and convinced Shire, tall and long-legged, to run up the steps. He ran alongside, filming her. Brown spent his last dollars

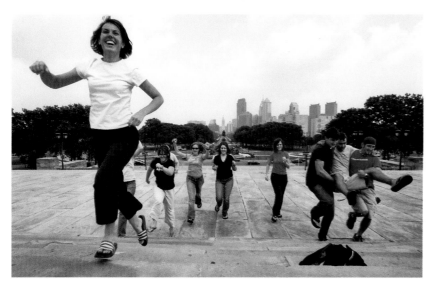

making the demo and shopping it in Hollywood. He didn't even have the money to pay the lab bill. Brown sold the right to manufacture his invention to the Cinema Products Corporation, which changed the name to the Steadicam, but Brown kept possession of the actual camera since he was the only person who knew how to use it. He was hired to shoot a scene in the Woody Guthrie biopic *Bound For Glory* (for which cinematographer Haskell Wexler won an Oscar in 1976)—his first official gig.

A few months later, the demo tape made its way into the hands of John G. Avildsen, who had just signed on to direct *Rocky*. Avildsen had two questions for Brown: "How did you do that?" and "Where are those steps?"

Sylvester Stallone had written the scene of Rocky running the art museum steps into his original script, but Avildsen had no idea how he was going to film it. He had no cranes or other high-budget equipment.

But the Steadicam helped make all the difference. "The genius of *Rocky*," film historian Jeanine Basinger once told *Philadelphia Inquirer* movie critic Carrie Rickey, "is how it used the Steadicam not merely to create movement, but to get us into Rocky's shoes and his skin."

The day of the filming outside the art museum started before dawn. Stallone, Avildsen, Brown, and the crew were scheduled to shoot both sequences that morning: the one in which Rocky runs halfway up the steps and fades, and the one where he bounds to the top in triumph. "It was cold and I was tired," Avildsen remembered. "I don't think we were at the steps for two hours. We were in a hurry. We had a lot to do that day."

On the morning that the now-legendary scenes were to be filmed, Garrett Brown dropped his one-of-a-kind Steadicam on the steps and bent one of the shafts. As a result, the camera's battery had to work extra hard to drive the mechanism. The December morning was brutally cold, and

the battery couldn't generate enough juice for more than a few seconds' filming. Brown wasn't about to let that stop him. He dispatched his assistant, Ralf Bode, to buy two automobile batteries. "We hot-wired the camera to the batteries with jumper cables, and Ralf ran up the steps beside me carrying two car batteries with his arms being yanked right out of the socket."

Brown went on to win a special Academy Award for technical achievement in 1978 for his Steadicam. He has since developed a number of variations, from the Skycam, which flies over sporting events suspended on wires (and for which he won a second Academy Award), to the Mobycam, an underwater camera invented for Olympic swimming events. His work with the Steadicam has involved him in more than a hundred movies, including *Tootsie*, *Philadelphia*, and *Indiana Jones and the Temple of Doom*.

He explains the lasting power of the scene at the Rocky Steps this way: "This is a peak, a pinnacle, that is accessible to people. It's so astonishing...It's not like climbing the damn Alps, you know. It can be done in thirty seconds. If it was as easy to get up Everest, there'd be people running up that and dancing on the top of it. It's that kind of thing. It's an odyssey, a personal odyssey and a transformation, and I think people either wish for or celebrate transformations in their own life by doing this."

Even though he lives in Philadelphia, Brown says he has not been back to run the steps since he filmed the *Rocky* sequels. "When I'm tottering around on a walker in twenty years, I think I may just go back up there one last time and make my way up to the top. The great thing is, it will still be there and still be open." ★

SPRING

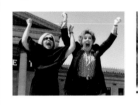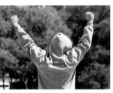

11 AFFAIRS OF THE HEART

★ What I loved most about this story was it was so many things at once—a triumph of the human spirit, a testimony to friendship, and evidence that love always seems to find a way.

"EVERYDAY I AM ALIVE WITH MY NEW HEART IS BEAUTIFUL."

For weeks, Jesse Galle avoided the truth. He couldn't breath; he coughed blood. He finally went to the hospital the night before his brother's wedding. That's when he found out he needed a new heart. His brother went ahead and got married without him—250 people were coming, what else could he do? Their parents missed the wedding, too, staying at Jesse's bedside. Everyone said a prayer during the ceremony.

Jesse was eighteen, a healthy, happy college freshman when a virus attacked his heart, causing cardiomyopathy. No one knows why it happened. Jesse, from Bethlehem, Pennsylvania, was transferred to the transplant unit on the seventh floor of Philadelphia's Temple University Hospital, known as "Heart Failure Hotel."

Jesse had been working at a summer camp, and a counselor, Becky Carter, whom he really didn't know very well, visited him that first night at Temple. Jesse was hooked up to so many tubes and monitors; he looked terrified, and so did everyone around him. "Some of the people around Jesse were talking about him as if he wasn't there and were talking about the things he would never be able to do again," recalled Becky. "That kind of talk didn't seem appropriate to me." She asked him straightforward questions—about his frame of mind, the plan for his medical care.

As Becky was leaving, Jesse told her, "You should come back. You're easy to talk to. You don't talk to me like I'm dead or treat me like I'm broken."

Becky lives in Allentown, an hour from Philadelphia. She drove in several times a week. "I can't quite describe how our friendship evolved, especially so quickly, but it was quite natural and easy," she said. "We were in a space where everything was real, the kind of honest space that opens up when you clear away all the bullshit, strip life down to its barest, most important pieces, and look at it with honesty and courage."

Often they talked late into the night. "Everything was safe to say and nothing was off limits," said Becky. On the night of September 7, after a month in Heart Failure Hotel, Becky asked Jesse if he was afraid. He replied, "Fear is bullshit." He told her that "rational fear" is when a "bear is about to eat you, or you're about to get carjacked," and "that kind of fear is helpful." Irrational fear is the kind of fear that grips you when you helplessly wait for a heart transplant, a fear that could only lead to negative thoughts, and negative outcomes. He refused to submit to it. She went home and wrote that saying, "Fear is Bullshit," on a post-it note and stuck it on her refrigerator, where it remains. The next morning, Jesse got a new heart.

Four years later, Jesse and Becky are still good friends. In fact, she is dating his roommate, Leigh Abraham, whom Jesse met when he returned to college. Jesse introduced them to each other. Becky and Leigh came to Philadelphia to walk with Jesse in a march to raise awareness and money for organ donation. The steps were mobbed that day, but the three friends all "rockied" at the top.

"Everyday I am alive with my new heart is beautiful," said Jesse. "I value life more. I don't get caught up in the small things that seem to stress out a lot of people, such as schoolwork, job, a broken air conditioner. I am good at accepting things the way they are now. There are more important things to me like my family, friends, life, what happens to me when I die—not what grade I got on some overnight assignment. I'm not sure what I want to do with my life. I hope whatever it is, I will do it with conviction and enthusiasm."

12 MOOSE

★ Nobody stood more silently at the steps than Moose.
It seemed as if he were praying, or connecting with his
father's spirit. The Rocky Steps offered a special solitude,
and solace, for him.

**MOOSE WAS ALL
BUSINESS, LOST
IN THE MOMENT.**

Michael A. Glorioso, Jr., "Moose," is a twenty-two-year-old senior at Salisbury University in Salisbury, Maryland. The oldest of seven children, Moose was a typical college student, enjoying the good life while his parents paid the tuition bill. His freshman year, he played nose guard on Salisbury's football team. In February of that year, his father died of a heart attack. Michael A. Glorioso, Sr., was only twenty when Moose was born, and never went to college himself. "He was a self-made man," said Moose. "He owned his own business selling medical software to doctors." Moose and his father had loved to go fishing together off the Maryland coast for tuna and shark in the summers, and his father had so looked forward to his son's graduation from college. Father and son had talked on the phone every day that Moose was at Salisbury.

Everything in life changed after his father died. Moose had to quit the football team and pay his way through school, working two, even three jobs to earn tuition and rent. He worked as a cook at a restaurant, a bouncer at a bar, and he took a full course load, trying to complete a double major in history and political science.

"I feel it is very important for me to finish college because I want to be an example to my younger brothers and sisters," he said.

In April, Moose came to Philadelphia with Salisbury University's history club. They visited all the places you would expect: Independence Hall, the Liberty Bell, South Street, Society Hill, the National Constitution Center—and the art museum steps. That is what Moose wanted to do most of all. He's a heavy, jiggly man, and watching him run—gallop—up the steps, it was easy to see how he earned his nickname. Many classmates horsed around at the top, but Moose was all business, lost in the moment, arms raised, eyes closed, bouncing up and down, "rockying" to his very core.

"Sometimes in his sleep he yells 'Adrian,'" said one classmate.

"Rocky is his role model," explained another.

"He's a gentle giant," offered a third.

"Running the steps was always a dream of mine because I have always looked up to Rocky," said Moose, who plans to teach high-school history. "I see him as one of the great American heroes, even if he isn't a real person. He shows how, with hard work and dedication and a belief in one's self, you can achieve anything. I think it was important for me to run up the stairs because it is representative of the mountain that I've had to climb in the past couple of years.

"I will always miss my father and to this date have not even visited his gravesite yet. But I know that the day I graduate I want to drive two and a half hours home to his gravesite with my robe on and diploma in hand and show him.

"I know he will be smiling down from heaven and I can say, 'I did it.'"

13 NOT IN KANSAS ANYMORE

★ Sometimes in the course of reporting a feature story, the unexpected happens. A source will utter the perfect quote or reveal a delicious detail. It is a reporter's "Eureka" moment. When she revealed that she hums the theme song at work, Valerie Rohlman proved my theory: *Rocky* is everywhere—even in Kansas!

Dr. Valerie Rohlman is a specialist in infectious diseases from Valley Center, Kansas. She attended the University of Kansas as an undergraduate, where she lived on a scholarship hall and met her four best friends in the world.

Valerie, forty-four years old, came to Philadelphia for a conference on epidemiology, and one of those four best friends—Joy Echer, now a lawyer in New York City—drove down to visit her. It was a glorious morning in April, and for the first time in her life, Valerie played hooky from a medical conference. The two old friends took a walk.

They meandered through the city and up the Benjamin Franklin Parkway, until they came to the Rocky Steps. Valerie was lost in thought, catching up on life, kids, careers.

"These are the steps that Rocky ran," her friend told her as they stood at the bottom.

They walked up. They did not run. Among the quintet of best friends, which includes two marathon runners, these two are known as the couch potatoes. "I make a valiant effort to work out," said Valerie, "but it's a conflict often with 7 A.M. meetings."

At the top of the steps, Valerie was overwhelmed by the view, the moment, the spirit of Rocky. "I didn't appreciate from the movie what a beautiful view it is," she said. "And you do feel like you're on top of the world. You do feel like you climbed a mountain."

She began to "rocky." And then Valerie made a confession.

"I have moments in my life when the theme song from *Rocky* goes through the mind, when

THEY FELT... LIKE THEY HAD PULLED OFF SOMETHING ALMOST IMPOSSIBLE.

I hum it out loud," she said, "after I've accomplished something that I didn't think I'd be able to pull off."

"You really have those moments?" Joy asked.

Valerie smiled broadly and then shared a story. At a hospital in Wichita, she directs a program called Antibiotics Streamlining. Because there is so much resistance now to antibiotics, her job is to review the prescriptions of other doctors and, if she feels it is warranted, to urge them to change their prescriptions to antibiotics more directed to attack a specific bacteria, or ones that might have fewer side effects.

At first, many doctors refused her suggestions. They felt they knew better. Whenever Valerie and the pharmacist working with

her succeeded in getting a doctor to change, they felt like Rocky Balboa—like they had pulled off something almost impossible.

"We would hum the *Rocky* song," Valerie said, and she broke into song right there on the steps.

The program has been around for ten years, and most colleagues readily agree to her suggestions now. But still she hums the *Rocky* theme.

"Every time?" asked her friend.

"Oh yeah."

14 ROCKY: THE DOG

★ I was looking for a rich variety of stories. When I saw a couple walking their dog up the steps, inspecting the Rocky sneaker imprints at the top, I had to ask them who they were, why they were here. When they told me the dog's name was Rocky, I knew I was about to add an essential piece to the book—a pet story.

Rocky was a doomed pup. Discarded. Headed for that final knockout by lethal injection, just like millions of American dogs every year.

But the Summit Animal League in Summit, New Jersey, brought him to an adoption day at a local pet store. It was Rocky's last chance.

A dog-lover rescued Rocky. She couldn't keep him, she already had two other rescued dogs of her own. But she had the perfect home in mind—she called Bob and Debra Rosenbaum.

Bob and Debra once owned a dog, the same breed as Rocky, a Cairn terrier, which had died at the age of eighteen. Now there was an emptiness in their lives,

and Bob and Debra fell fast and hard for Rocky, five gentle pounds of fluff and love.

Rocky got a new home, his life was spared, and he made the world a better place almost immediately.

"When we first adopted him, our son was in eleventh grade," said Debra. "His best friend had grown up afraid of dogs. Our son was very excited and couldn't wait to introduce Rocky to his friend. At first, the friend was reluctant to even go near the puppy. But Rocky persisted. Eventually he managed to undo fourteen years of fear that had been instilled in this child. I still remember one night when our son's friend slept over. I went to find Rocky, and found he was curled up and asleep

in bed with the boy, and the boy's arm was around Rocky!"

Bob and Debra never knew why the dog was named Rocky. He came to them that way. They accepted it as fate since *Rocky* is one of their favorite movies.

"The underlying theme of the movie is universal—triumph in spite of overwhelming odds," said Debra. "It is a message that resonates universally, both for humans and at least for one lucky dog. The fact that we ended up with a dog named Rocky is just a remarkable coincidence."

Their dog has a wonderful life. Both Bob

"THE UNDERLYING THEME OF THE MOVIE IS UNIVERSAL—TRIUMPH IN SPITE OF OVERWHELMING ODDS."

and Debra work near their house, and one of them always comes home at lunchtime to walk Rocky. He greets them at the door with his bones and doggie toys. Neighbors joke that in their next lives they want to come back as Bob and Debra's dog.

In April, Bob and Debra were going to Philadelphia to attend a concert. They decided to bring Rocky (he had his own bed at the Loews Hotel). He was now five, and it was time. On a glorious Sunday morning, they visited the Rocky Steps with him, to celebrate a dog's life. No bounding up the steps—but a celebration, just the same.

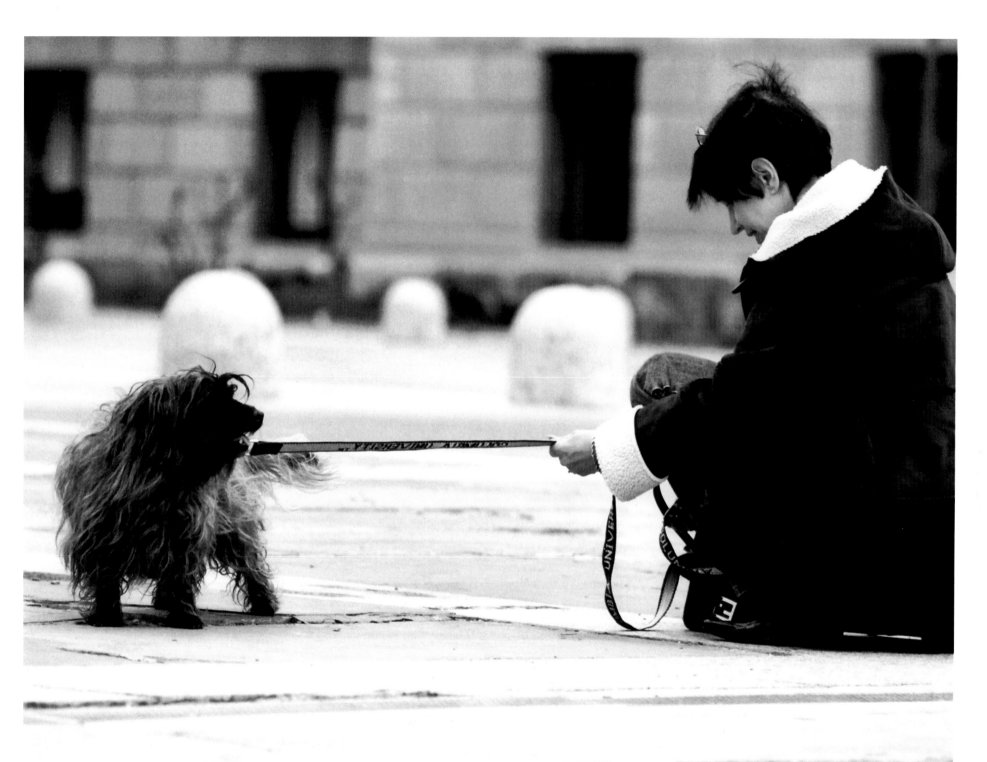

15 BIG EYES

★ I could see the passion in Ojon's face as he ran. This experience meant something to him. I love people who love what they do. I only wish Ojon had brought his bicycle with him from Boston. That would have been fun to watch—him riding down the steps as fast as the wind.

As a boy growing up in Mexico, Gerardo Bojorquez Garcia was called "Ojon" by his family and friends—a term of endearment meaning "Big Eyes." Big Eyes also had big dreams. After winning national road- and mountain-biking championships in Mexico, he moved to Boston to train for a new variation of bike racing that he had come to love: sprinting down mountains.

Ojon loves all things related to bicycles. As his girlfriend, Katie Milton, explained, "He works as a bike mechanic at a bike shop. All his future plans and dreams involve bikes. He would love to own his own bike shop. He says he wants to work with bikes, fix bikes, design bikes, sell bikes, talk about bikes."

Katie, who had lived in Mexico after college, met Ojon—she calls him Gerry—at a concert last year in Boston (a Mexican rock band performed). They are both idealistic, generous people, and they hit it off right away. Katie is in law school, and she has a dream of her own: to become a public-interest lawyer and to fight for the underdog.

In May, Katie and Ojon took the bus to Philadelphia to visit friends for the weekend. Ojon is a passionate *Rocky* fan who watched all five movies over and over while growing up in Sonora, Mexico. He couldn't wait to get to Philadelphia and run the steps. His first professional bike race sprinting down a mountain would be the following weekend, with competitors coming from all over the world. Running the steps would give him the motivation he needed. His one regret was that he couldn't bring his mountain bike on the bus from Boston and pedal down the Rocky Steps. *That* would have been sweet.

They almost didn't make it to the museum steps. Katie and Ojon went to a big party Saturday night and didn't get to bed until after 4 A.M. "I honestly assumed we would just see the stairs the next time they were in town," said their friend and host, Bethany Morris. "We all climbed into bed very late, and Katie and Gerry were leaving town at noon on Sunday. I set an alarm thinking I would yell upstairs to them that we needed to leave ASAP if he really wanted to see the stairs, and I was sure that they would say 'Forget it.' Not

"I WOULD LIKE TO HAVE A MANAG- ER LIKE ROCKY."

a chance—Gerry bounded out of bed and was ready to go!"

Ojon flew up the steps, leaving Katie far behind. He is a sprinter, after all. She has run the Boston Marathon twice, but this morning she couldn't keep up. Ojon celebrated at the top.

"He's waited for a long time to do that," Katie said.

"I was feeling like I need to feel Rocky in me," he said, "to feel professional."

At twenty-six years old, Ojon wishes he had one thing that Rocky had. "Rocky had a manager," he said, "someone who believed in him, who pushed him, who encouraged him to be all that he could be. I would like to have a manager like Rocky. But I do the best I can on my own."

16 BUY ME A CHICKEN

★ David Donegan could get altitude on his jump like nobody's business. He soared. He told me of lots of adventures he'd had. Running the Rocky Steps was one more he could cross off his list.

Ever since he fell in love with *Rocky* as a boy, David Donegan had wanted to come to Philadelphia to run the art museum steps. David grew up in a small, industrial, blue-collar city in England, and he recognized his hometown in the gritty Philadelphia he discovered in the movie.

Running the steps was on his list of adventures. "But the first time I ever thought I'd really do it was when I met Kate," he said. "That was my chance."

David met Kate Brown, from Philadelphia, when both were teaching English in Japan in 1999. Amazingly, she had never seen *Rocky*, and he took her to a Japanese video store to rent it. David was always slightly confused that she didn't have an accent like Sylvester Stallone's in the film.

"Why don't you talk like him?" he would ask.

"Because I tried so hard *not* to talk like him," she would reply.

After teaching for a year, they returned to their respective countries. She started her own freelance writing and editing business; he got a job in London teaching English to African refugees.

She repeatedly tried to lure him to Philadelphia, even sending him emails with photo attachments of the Rocky Steps. When he finally decided he would come, when the lure of the steps became irresistible, he began sending her requests. For instance, he ended one email: "Can you buy me a chicken? I have plans." (David's plan was to chase it around, just like Stallone did in *Rocky II*.)

"I'm not buying a chicken for you," she wrote back, "because then what am I going to do with it? I'm not going to kill it. Am I supposed to keep it on my back patio?"

David arrived in Philly from London late one night in April. First thing in the morning, he ran through the Italian Market, as Rocky does on his way to the museum steps. "I was hoping somebody would throw me an apple, just like they did to Rocky in the movie," he lamented. "Nobody did."

He had wanted to run the steps with hundreds of schoolchildren following him, the way it happened in *Rocky II*. As fate would have it, as he reached the steps that morning, several school buses arrived and he got his wish—only he had forgotten his camera. A week later, just two hours before he was to catch a plane back to London, David returned to the steps to run them again, this time with his camera. But

"IT'S SO HARD TO GET OUT OF THE ROUTINE, TO ACHIEVE SOMETHING."

there were no children in sight.

After his run, he reflected. "In *Rocky*, it's not that he wants to win the fight. He just wants to last the fifteen rounds, to show that he's not a bum, that he's doing something with his life. It's so hard to get out of the routine, to achieve something, to be something special. I think that resonates with a lot of people. With me, like with what I do, these refugees have a tough time, and it's very hard for them to be something, to get above it, to get ahead. And for me, Rocky was the same kind of thing. He just wanted to be something, for Adrian as well as for himself."

As the two left the steps and headed for the airport, Kate knew she'd have to think of a new excuse to entice David back to Philadelphia.

17 TWO PIGS IN A POKE

★ I loved these guys. They were smart, clever, original. They were uninhibited, just being themselves. With their friendship, their friendliness, their sense of fun, people like Tom and Douglas make it easy for me to be an optimist.

It is hard to draw a connection between *Rocky* and pigs. Rocky may act like a pig, briefly, when he gulps down five raw eggs and wipes his mouth on his sleeve. And he does go into a meat locker and pound the carcasses until his knuckles bleed, but alas, he's pounding beef, not pork.

Tom Ng and Douglas Cheung love pigs. So do their wives. After Tom and Linda got married, they had their wedding pictures taken at the Vancouver Zoo, so they could pose with a six-hundred-pound pig. They have collected more than two hundred pig-themed items: pig telephone, pig alarm clock, dishes with pig prints, pig tea kettle. Their house,

says Tom, is "literally a pigsty." Tom has loved pigs since high school, when he wrote a poem about pigs for his tenth-grade yearbook. He has always loved their snouts, their noises, their personalities.

Douglas has a simpler explanation. He was born in the year of the pig. He doesn't have quite the collection of pig paraphernalia that his best friend has, but he calls his wife "Piggy" (her real name is Amy), though she is anything but porcine—trim and beautiful. Both men were born in Hong Kong, but they have lived most of their lives in Vancouver, British Columbia. Douglas, forty-four years old, is an architect, and also

an artist. He designed a tattoo for Tom and Linda—an abstract vision of two pigs hugging—which Tom had tattooed on his chest. Tom pulled down his shirt, revealing the work of art.

"Very abstract forms," explained Douglas. "More like a Picasso."

"It's not a Picasso," interrupted Piggy. "It's Pig-casso."

A few years ago, Douglas and Piggy moved to New York. They left their best friends behind in Vancouver. The Canadians came to visit the New Yorkers in May, and they all decided to take a weekend trip to Philadelphia.

"WE HOPE TO ACHIEVE GREATNESS IN OUR LIFETIMES."

That's when they came to the Rocky Steps, not just to run them, but to create art on them. Tom and Douglas wanted to make a movie of themselves running the steps.

"Ever since I saw that movie," said Douglas, "it's always my dream to come here and do this movie."

"You're full of it," said Piggy.

The women went into the museum, while the men filmed each other on a hand-held digital camera that could take short videos, starting at the bottom and slowly working their way to the top. Genius is often slow: they considered every angle and artistic flourish. Tom even lay on the steps, pointing his camera to the

sky as Douglas ran past, so he could get the American flag in the background. They became so engrossed that they occasionally lapsed into their native Cantonese.

At the top, it was time for the final scene. Tom held the camera and directed Douglas to run up the last few steps, raise his arms and dance, and then, finally, to drop them to his side, turn his face to heaven, and scream with all the passion he could muster, "Adrian!" (Rocky screams for his true love in the boxing ring, not on the museum steps, but visitors to the steps often cry out for Adrian.) Douglas followed direction beautifully. He was better perhaps than Stallone himself. He

bellowed, "Adriannnnnnnn!" with such zeal and pathos that tourists all around them at the top of the steps began to howl with glee.

"Finished," said Tom. The best friends laughed.

The two men could not draw any connection between their passion for pigs and their joy in recreating Rocky's greatest moment. But they did get philosophical: "We hope to achieve greatness in our lifetimes," said Tom, "but if given the chance, can we grasp it and run with it like Rocky did? Can many of us even identify such a chance if it presented itself to us when we get out of bed tomorrow morning?"

18 JUBILEE

★ More than anything else, this is a story about friend-ship. I loved that these two women had been friends since slumber party days in grade school—and here they were, celebrating that friendship in a moment of exuberance at the Rocky Steps.

Ann McCoy and Dora Horn have been best friends since they met at a slumber party in ninth grade in Ardmore, Oklahoma. Later, they were Tri Deltas together at Oklahoma University, where both majored in art history. "We've always had art as a common denominator," said Ann. "She can stand in front of a piece of art just as long as I can, and we're not going to bore each other."

Ann settled in Denver and became an interior designer. Dora married an Air Force fighter pilot, had twins while he was flying missions in Vietnam, and lived the quintessential military life, moving twenty-four times in thirty-six years. For the record, that included Canada, Germany, Alaska, Hawaii, Phoenix (three times), Washington, D.C. (twice), a dozen or so others places, and for the moment, Pennsylvania.

"It's not an easy lifestyle," said Dora. "But I look back, and I wouldn't change a thing—even in the worst of times, even when Van's fighter-pilot buddies would crash. Who picks up the pieces?"

The families you're living with on base."

Ann and Dora have stayed best friends despite all the different zip codes. Both women turned fifty-nine in 2004. Ann, in Denver, came up with the notion of calling it her Jubilee Year. Every month, in celebration, she was going to do something special. In May, she flew to Philadelphia to visit Dora, and they went to the Philadelphia Museum of Art.

Dora loves the museum and wanted to be sure her best friend saw it. "They have a wonderful collection," said Ann, "and the building itself is so fantastic. The beauty of that stone is magical, I think. It's just a magical building."

After they toured the Impressionists galleries, Dora announced that they were going to go outside, to stand at the top of the museum steps, and celebrate like Rocky. "I hadn't seen the movie in nearly thirty years," Dora recalled. "I think it's just a moment that nobody forgets, that feeling of elation." And that's what she was feeling now. Dora and Ann had been friends for forty-five years. Between them, they had overcome or endured so much: a divorce, a life-threatening illness, financial hardship. Both had raised wonderful children.

Ann was dubious. But as they approached the steps, she couldn't help herself. Running was out of the question for these ladies, one in pearls, the other in pumps. But they did dance at the top of the steps, even going airborne for a moment.

"I wanted for history, for our children, a historical photograph to prove that we were at the Philadelphia Museum of Art, in Rocky's footsteps," explained Dora. "And we have triumphed also, over many things, like Rocky."

"I felt caught up in the moment," said Ann. "I saw everybody else. The whole thing was truly in celebration of the Jubilee Year. When you have this much life under your belt, you have survived. I felt jubilant and triumphant."

"WE HAVE TRIUMPHED ALSO, OVER MANY THINGS, LIKE ROCKY."

19 MASTERPIECE . . . OR DISASTER

★ When I noticed these two, they were casing the place—walking the steps, standing around, looking for other runners. They wanted to run, somehow I knew they were going to run, but there was a *Rocky* inhibition issue. I waited and waited, and I was right! People's dreams and desires are so broad and diverse and surprising: Here is a man from Italy who travels across America to visit locations from movies he admires. Well, why not?

Louisa van Houten was invited to the party; Walter Taffarello just crashed it. He was from Italy, officially in the United States for six months to study political science and learn English—but really to see as many American movies as he could. She was pursuing a master's degree in Teaching English as a Second Language at UNC-Charlotte.

"We got engaged on top of the Empire State Building, like in many movies," said Walter, "but that day I just wanted the highest spot in Manhattan to say 'I love you.'" They got married in Italy, in a fairytale wedding, and moved to Weehauken, New Jersey, outside New York City, where both got jobs. After they were settled, Walter wanted Louisa to take him to Dallas, so he could see where President Kennedy was shot (*JFK* by Oliver Stone). He wanted her to take him to Washington, mainly to see the Watergate building (*All the President's Men* by Alan J. Pakula).

"I don't spend all my time trying to find movies," confessed Walter, thirty-three years old, "but, yes, I like to live America through movies."

Of course, Walter also wanted Louisa, thirty-one years old, to take him to Philadelphia, to the steps of the Philadelphia Museum of Art. "Only a few movies last forever in our memories," said Walter, and for him, *Rocky* is one. (He had a speech impediment as a child and believes Sylvester Stallone had one, too.) Walter also considers the *Rocky* theme song "a masterpiece."

Louisa explained that Walter is fiercely opinionated—one of the things she loves most about him—and to him, everything in America is either a "masterpiece" or a "disaster." "This also means that some days I'm a masterpiece," she continued, "and others my reviews are less than stellar."

Walter wants to be like Rocky in his own way: provide for his wife, become a good father one day, and take care of his parents and family back in Italy. That's his dream. "One day I want to go on top of a ramp of stairs and look down on my life and be able to raise my arms and say 'Yes, I've done it. Well done, Walter.'"

One of the things Walter likes best about the movie is that Rocky could never have become the man he became by himself. "At the end," Walter said, "you always need the support and love of some people."

Louisa provided an example of that love and support on the Sunday of Memorial Day weekend, when she and Walter came to run the Rocky Steps. They stood on the plaza at the top of the steps and watched for fifteen minutes. Nobody else was running! Walter was beginning to get discouraged. He was thinking about giving up, going home. Then Louisa stepped in—"OK, listen. If it's going to make or break your day, let's do it," and she led him down to the bottom.

They ran back up the steps together and celebrated at the top. Walter felt elated, lighter than air. Without Louisa, he never would have run the steps, and he knew it.

They returned to Weehauken that night. "We woke up Monday morning with an indescribable energy," Walter told me later. "We went to the reservoir in Central Park and did four loops like in the movie *Marathon Man* with Dustin Hoffman. But believe me, we ran fast—like Rocky."

"ONLY A FEW MOVIES LAST FOREVER IN OUR MEMORIES."

20 THERE IS NO TOMORROW

★ Raman flew East just to run the steps. That was the only reason he came on vacation with his family from California. After I'd had a long conversation with his mother, I realized that she and her husband reminded me of my own parents, immigrants who arrived here with nothing and built great lives for themselves. Raman's run up the steps was a statement that he was going to succeed, too.

I remember when he watched *Rocky* for the first time," said Penah Dadayan, speaking of her son, Raman, now nineteen years old. "He was so much in love with the movie that he started recording the movie on VHS, and after that he watched it over and over and over. I remember him repeating the sentences while he would watch the movie. And after *Rocky II* and then *III*, *IV*, and *V* were out, he recorded all five movies, and he would watch them regularly" (at least a hundred times each, Raman insists).

"He would play the background music so loud in his room and study at the same time," Penah continued. "I think what inspired him was the character of Rocky. Somehow, Raman identified with him. He was a poor person, with little education and no help, and he followed his passion and made it to the top."

Why does Raman so identify with Rocky? He was two and a half when his parents left Iran for America. "We spent all of our savings just to come to America and experience freedom," said Penah. "After we rented a small apartment and bought a very old car, we barely had money to buy food. My husband started working as a construction worker or carpet installer, and at the same time he went to school to learn English. I started going back to school, learned English, went to college, and after ten years I became a doctor of pharmacy. My husband became a dental technician. Now we have our own house and enjoy living in this great country. I think Raman saw how we overcame obstacles in life, just like Rocky, and that inspired him to know that everything is possible."

Raman, himself, graduated from high school with honors. He and his family live in Los Angeles, where he is attending Modesto Junior College and working part-time. If his dream of playing pro football doesn't work out ("I'm not that big of a person, sort of skinny, but you don't need that big of a body, all you need is heart"), Raman likely will follow his mother and go to pharmacy school.

He knows virtually every line from all the *Rocky* movies, but his favorite is "There is no tomorrow." He explained: "It's because that's how you have to go through things sometimes. Not just sports, or boxing, but through life. You have to have that 'no tomorrow' attitude in order to be at the top of your game. You have to do whatever you're doing as if there is no tomorrow, as if you only have one shot at it."

When Raman came to the art museum in May with his mother, father, and uncle, he was tentative. He walked all around with his family, up and down the steps, but needed to build up his nerve. All his life, he'd wanted to run the Rocky Steps, but actually doing it, in public, took courage. His mother and father and uncle goaded him and pushed him. Finally, they waited at the top as he ran to the bottom. He rocked back and forth at the bottom of the steps as they gave him a countdown— "five, four, three, two, one"—and then he took off. Wearing baggy jeans and a pro football jersey, he sprinted up the steps, "rockied" at the top for a moment, but didn't stop there.

His uncle told him to keep going—the man obviously had never seen the movie—so Raman continued on. Why not? He'd run the Los Angeles Marathon twice. What was another fifty yards? He ran across the plaza, past the fountain, up the twenty-six steps leading to the front door of the museum. He even tried to open it—would he have gone inside? The museum is closed on Mondays, so he "rockied" some more next to the enormous columns. He was sweating profusely, but he was happy.

"I had my chance," he said proudly, "so I took it."

"YOU HAVE TO
DO WHATEVER
YOU'RE DOING AS
IF THERE IS NO
TOMORROW."

21 CHARGE OF THE WEDDING PARTY

★ One of the greatest surprises, and moments of joy, at the steps came when two limos pulled up and six tuxedoed men jumped out and began running. Maybe this is how a '49er felt when he discovered gold. Who were they? Would they tell me their story? (Would they have time, or did they have to rush off to the ceremony?) I couldn't wait to find out.

SEAN OPENED THE LIMOU-SINE DOOR AND SHOUTED, "UP THE STAIRS, BOYS!"

On a warm, gorgeous Saturday evening in late May, two limousines, one black, one white, pulled up to the steps of the Philadelphia Museum of Art. From the black limo emerged six men, all in tuxedos: the groom, his best man, and four ushers. They scrambled up the steps, laughing wildly and punching the air as they went. One of the ushers lost his boutonnière, a white carnation, during the charge. At the top—euphoric from champagne and the swift climb—they all danced and hugged before bending over, exhausted.

The bride and her maids waited at the bottom for their men, who, once they had regained their feet and their wind, descended just as quickly and joyfully as they'd gone up.

"We're friends from high school," exclaimed Kevin Giambrone, thirty years old, a groomsman.

"The theme of our freshman year was *Rocky*, and we said one of us has to get married in Philly, has to run up the steps. I swear. So we're all here."

The groom—the last of the group to get married, and the one, finally, to fulfill the pledge—was Sean Haubert, twenty-nine years old. Sean, Kevin, Eugene Hagan, and Edward Ramos all met freshman year at Burke Catholic High School in New York in 1988. Sean and Kevin met the first day of school in homeroom. By year's end, they were as tight as brothers. During their junior year, with the release of *Rocky V*, their *Rocky* fever peaked. That's when the pledge was made.

Of course, the years went by.

Sean fell in love with a Philly girl when he was living in Boston and she was in graduate school in New York. While they were dating, they often drove to Phila-

delphia to visit her family. "On one of our first visits here," Sean said, "I made her drive me to the art museum so I could run up the the Rocky Steps, remembering how I always wanted to do it in high school. She laughed at doing such a touristy thing, but obliged me." His future bride moved to Boston, and they were engaged. A year ago, they moved to Philly.

On his wedding day, Sean drove his groomsmen to the church in his own car, with U2 blasting on the radio, just like in high school. "It was at that moment," said Sean, "I remembered how we always wanted to run up the stairs and do the Rocky thing. I wanted to keep it a surprise."

The wedding went off without a hitch. After the ceremony, Sean piled the boys into the black limo and headed for the art museum. Nobody knew where they were going or why. The girls followed

in the white limousine. When they arrived at the museum, Sean opened the limousine door and shouted, "Up the stairs, boys!"

His pals were shocked. But the high-school buddies immediately remembered the pledge and gleefully took off.

"We all did it!" exclaimed Kevin at the top.

"He pulled it off," panted Ed, in awe.

"He pulled it off," echoed Eugene.

"I'm tired," confessed Sean. "I think I've had better ideas in my time."

Like his next one, perhaps—On the way to the reception at the Franklin Institute, the limo stopped at Logan Circle just down the Benjamin Franklin Parkway and several of the wedding party took a dip in Swann Fountain.

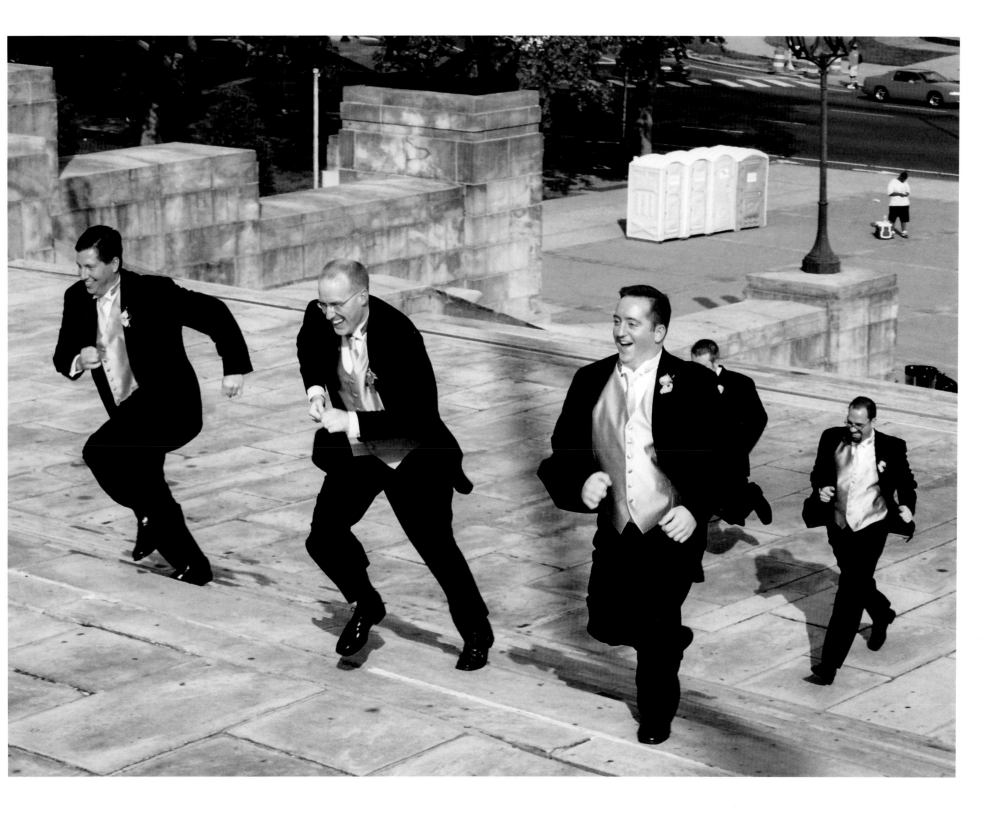

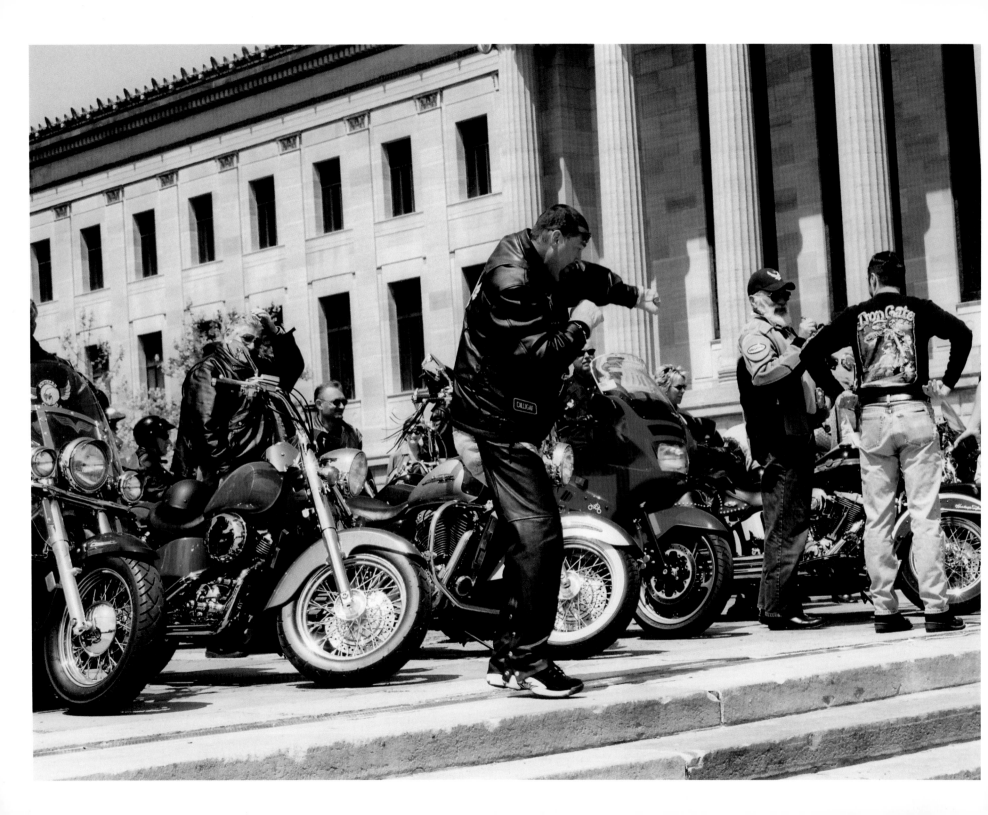

22 MOTORCYCLE MAN

★ When a man like Paul DeFelice shares his story with me, I feel privileged. It can't be easy telling a writer—and hence, the world—how messed up you were. That's one of the beautiful things about the Rocky Steps: they are a catalyst for joy. A man got a second chance in life, and his happiness overflowed while he was here.

Paul DeFelice is the comedian of his motorcycle club. He keeps the others laughing. But he has a lot to be happy about in his own life, and he knows it.

"I feel I'm living a second life today," Paul explained. "I had a life of drugs that a lot of people would have died from. It started when I found pills that made me feel like I was invincible. With a little beer and weed, I was king."

One day in his senior year of high school in the Bronx, he was so high a car hit him as he crossed a street. "I was told I flew in the air like a rag doll and landed almost a hundred feet away." He got a financial settlement from the driver of the car, but he and his girlfriend spent that on cocaine. "The money I made from the car accident," he said, "we put up our nose.

"After years of going nowhere and doing nothing, we got married." His wife eventually "grew up," got a decent job, and worked hard. Not Paul. "She was getting tired of getting me out of trouble all the time, bailing me out of jail, paying back money I borrowed for drugs," he said. "It was ugly. I was pond scum, and it was getting worse. I couldn't hold onto jobs and my wife was tired of me and my lying. It was the end for me."

When he was thirty-four years old, he finally entered a drug rehabilitation facility. "I cried a lot, made a lot of friends who kept me straight, prayed, and learned about my addiction. I came home after thirty days and felt like a real man."

Paul turned his life around. His marriage rebounded and remains strong. "Even my mom was proud," he told me. Three years ago, he and his wife had their first child, a daughter. "I am happy today, with a job, a wife, a baby,

LIKE THE MOVIE'S HERO, PAUL HAD BEEN GIVEN A SECOND CHANCE.

friends, even a dog who loves me. Everything is great."

Last year, Paul bought a Yamaha Road Star and joined the motorcycle club, the Southern Cruisers. He is forty-six years old now, has been drug-free for eleven years, and loves the sense of freedom and independence he gets from his bike. One day in May, he and his posse traveled to Philadelphia from northern New Jersey. Their first stop was the art museum. Paul had never been there before, and of the sixty riders, he was the most excited.

The husky roar of the bikes could be heard moments before they came into view, like a swarm of bees buzzing up the Benjamin Franklin Parkway, a thick cloud of black leather and chrome. They zoomed up and around the museum drive, parking their glistening motorcycles, one next to the other, all along the plaza at the top of the Rocky Steps. They silenced their motors and enjoyed the view.

Paul, a rough, tough, biker (who rides on two gel pads to protect his rear end from hemorrhoids), began yelling "Adrian!" into his headset microphone from a mile away, so all the other riders could hear him as they approached. Paul had seen all the *Rocky* movies, and he felt the spirit of the moment. Like the movie's hero, Paul had been given a second chance in life, and he'd made the most of it. Like so many who come to the steps, he couldn't really explain his strong emotions at the time, he just felt them. He was one of the first to climb off his motorcycle, and he immediately began to "rocky."

He jabbed the air and danced as he repeated his cry, "Adrian!" He was clowning around, entertaining the others, but he was also celebrating his own life. "I was kind of inspired by the steps, and being in Philly," he said. "I did feel it. I felt it, the *Rocky* syndrome, the whole thing."

23 THE ROWER

★ What I remember most about Kari Barber was her smile. Warm. Seeing her run and exchanging a few words with her, I sensed a kindness and a goodness. In subsequent interviews by email, I began to understand even better why she was so happy that day. This young woman is on her way, climbing the steps of life.

As a young girl, Kari Barber loved *Rocky* so much that she'd often pretend she was Rocky Balboa when she ran up stairs in San Francisco, where she grew up. "He was such an inspiration because he overcame adversities the hard way," she said. "He simply believed in himself and didn't quit."

She knows something about this. She went to an all-girls high school in Palo Alto, California, within walking distance of Stanford University. Everybody's father or mother seemed to be CEO of a biotech firm, a venture capitalist, or some other high-powered person, and their children were smart and ambitious. Kari had a learning disability—a test-taking anxiety—but she never knew about it until the end of her junior year.

"The whole time at school, I felt like the village idiot because everyone else just seemed to be that much smarter than me." She felt teachers didn't respect her, but she didn't quit on herself. Like Rocky, she worked twice as hard. She had to.

Her senior class was small, just sixty girls. A dozen went to Ivy League colleges. Another dozen went to Stanford. She traveled three thousand miles to attend Bowdoin College in Maine. Being accepted to Bowdoin—a highly regarded liberal arts college—marked the first time in Kari's life that she began to have confidence in herself. But it wasn't until she completed her first semester's work—getting A's in most of her classes—that she convinced herself she really was as good as everyone else.

At Bowdoin, she joined the crew team, and in the spring of her sophomore year, she competed in the Dad Vail Regatta, the largest collegiate rowing event in the United States, held on the Schuylkill River in Philadelphia. She was excited about rowing in the renowned regatta, but just as excited about doing one other thing when the regatta was all over. "No trip to Philadelphia would be complete without a run up the steps," she said.

In one preliminary race, disaster struck. But she summoned the persistence of Rocky. "I was in the stroke seat," she said, "and we were leading the pack when all of a sudden, with only 350 to 400 meters to go and the second-place boat right on our tail, my seat came off the railing." The other boat moved ahead. "You could either quit now and let the other people in your boat down," Kari told herself, "or you can give your all and finish the race." In the spirit of Rocky, she opted for

ROCKY "STANDS FOR THE AVERAGE AMERICAN MAKING SOMETHING OF HIMSELF."

the latter. "We were able to still get second in the race, which allowed us to go on to the semi-finals," she said. "What I learned from this is that, though you may face obstacles, you can still find out things about yourself that you never knew you had."

Her team finished third in the semis, just missing the finals. Kari still felt great about their effort; they had done their best, given their all. After her final race, she and teammate Lauren Johnson took a shuttle bus from the river over to the Rocky Steps. Kari had wanted to run up them carrying an oar, but hadn't been able to fit one on the bus, so she ran empty-handed, in her Bowdoin crew jacket. It was a gorgeous day in May, and she sprinted to the top effortlessly.

Kari believes that Rocky "stands for the average American making something of himself, and I think I see a part of myself in him." After college, Kari hopes to go to medical school, certainly a difficult road, but that doesn't discourage her. "I want to be a person that never takes the easy way out. I want to be a person that sees a challenge and has the confidence to say, 'I don't care what obstacles lay in my path, I'm going to achieve my ambition regardless of what adversities I am going to face along the way.'"

24 THE SURVIVOR

★ I went to the steps on Mother's Day because I knew thousands of breast cancer survivors, and tens of thousands of others, would be there, marching to raise money. I wondered if *Rocky* would be on anyone's mind. I stood at the bottom, scanning the steps, and there she was, thick in the middle of the crowd. She raised her arms in the classic pose. Now I had to reach her before she disappeared into the crowd. I needed to hear her story.

"I MADE IT," SHE THOUGHT. "WE ALL MADE IT."

When Sarah Nesmith was diagnosed with breast cancer, she didn't complain; she didn't cry, at least not in front of her children. "I did a lot of praying before the test results came back," she said. "I just asked God to give me the strength to deal with whatever. But my kids, they were really upset."

Sarah had surgery in 2002 and then underwent six months of radiation treatments. She didn't tell many people about the cancer, and asked her children not to tell anyone else. "She's always been a strong person," said her daughter Thomasina Cole, "never one to cry a lot or even be very emotional."

Sarah, now sixty-eight years old, has always been the rock. Born in the South, she moved to Philadelphia at age eighteen to find work and a better life. She worked twenty-eight years for the Department of Defense, sewing soldiers' uniforms. She raised five kids. All through her cancer treatments she continued to care for her ill husband—driving him to dialysis three times a week—and still watched many of her eight grandchildren while her daughters worked. She also continued to work part-time, behind the cosmetics counter at a Philadelphia department store.

Two of Sarah's daughters brought her to the Rocky Steps for the Race for the Cure, Philadelphia's annual Mother's Day walk/run to celebrate breast cancer survivors and to raise funds for research. As a survivor, Sarah wore a pink shirt and carried a pink carnation. At 7:30 A.M., three thousand survivors assembled at the top of the art museum steps.

Because this was Sarah's first time there, she walked up the seventy-two steps, slowly, by herself. When she reached the top—surrounded by a sea of pink—she turned, faced the city and the thirty thousand people below, and thrust her arms in the air—in victory, just like Rocky.

"As I walked up the steps, I remembered Rocky, when he went up here," Sarah said. Her ebullience, her Rocky-like gesture, was spontaneous. "I made it," she thought. "We all made it. We beat this cancer."

At the bottom, her daughters were shocked to see her display of emotion. "It was the first time we saw how happy she was, just to have gotten past this," said Thomasina.

At the appointed time, the throng of survivors paraded down through arcs of pink balloons in the annual Survivor Parade. Sarah walked down the steps, arm in arm with another survivor, a stranger. They were sisters for the moment. At the bottom, she saw her two daughters, both crying. Sarah began crying, too. "They know that I could have died, and they were so grateful to have me," said Sarah. "And I was free of it. And that touched me, too."

Mother and daughters made the five-kilometer walk together. For the first time, Sarah really talked about her experiences and her emotions with other survivors. "Everybody had the same feeling I did," she said. "They had it, and beat it. They were survivors, and we're still survivors. Each day of my life, I pray and thank God."

25 WHEEL OF FORTUNE

★ We happened upon Vanna White and her crew by accident, and oh, how we prayed she would run. Then, again, maybe we were lucky that she didn't and Joe did. He's a man who took a chance, walked away from a secure job because he wanted more. I wondered, would I take a chance on life the way Joe did? Quit my job and head west and sleep on somebody's floor until I could get a new start? Would you?

Rugby players are "different," and Joe Somerville plays rugby. That explains a lot about Joe, who is thirty-six years old and weighs 270 pounds. When he isn't playing rugby, he's working as a lawyer for the television game show *Wheel of Fortune*, which is how he came to be in Philadelphia in late May.

On the other hand, you could say that it was a true *Rocky* moment that actually led Joe to the art museum steps. After graduating from law school, he worked as an attorney in Atlanta, defending insurance companies in lawsuits. He took some time off in 1996 to volunteer during the Atlanta Olympics. When the games ended, he tried returning to work. "I got back to my desk, looked left, looked right, and thought, you know, 'Is this the end?' So I quit my job, moved out to L.A."

A rugby club gave him a place to live until he got on his feet and found his job at *Wheel of Fortune*. When the show goes on the road, it films promotional spots at well-known locations, such as the Rocky Steps. Joe's job is to make sure there are never problems.

In Philadelphia, the film crew was finishing a promotional spot that featured Vanna White across the street from the Philadelphia Museum of Art. Joe watched as a busload of schoolchildren piled out and ran the steps *a la* Rocky. "I thought to myself, 'I bet you these stairs have to be the most run stairs in the history of the universe.'"

Harry Friedman, the show's executive producer, challenged everyone in the crew to run them. "It was more of a dare than a challenge," said Friedman, "because I think everyone else sort

of thought about it, but thinking about it and doing it are two different things. Joe just went for it."

That he did. He took off, two steps at a time. Half way, gravity caught up with him. He thought to himself, "You know what? I can't stop, no matter what. Got to finish, 'cause, you know, they're all watching." Rugby players are accustomed to pain. But by the time he reached the top, a strange thing happened—Joe felt, well, as if he'd just won a million dollars on *Wheel of Fortune*. He spun, danced, threw a few punches: he was "rockying." "I was sixteen instead of thirty-six," he gushed.

Harry Friedman considered filming Vanna White running the steps. But it was a warm afternoon, and

"THESE STAIRS HAVE TO BE THE MOST RUN STAIRS IN THE HISTORY OF THE UNIVERSE."

he decided against it. "If it were earlier in the day, and we weren't going to be challenged with makeup, I would," he insisted. "I would."

Instead, Vanna stood at the top of the Rocky Steps and read from cue cards: "We're in Philadelphia! It's a week of life, liberty, and the pursuit of big money!" and "These steps were made famous in the Academy Award-winning movie *Rocky*!"

Joe, of course, had no issues with makeup. He loves his job, and he feels that *Wheel of Fortune* and *Rocky* have a lot in common. "*Wheel of Fortune* is about rags to riches. It's about the everyman, coming, taking a chance, and possibly going away a much better person, if not a much richer person. That's the Sylvester Stallone story, as well as the *Rocky* story." Maybe that's Joe's story, too.

26 THE DOCTORS

★ The first thing I noticed about this group was, I admit, how beautiful Emily was. But all three of these future physicians were filled with such promise. For Luke, running the steps was a test, a symbol of his recovery from surgery. He had waited all summer to try it, and he celebrated in victory at the top.

My mum has always said she wanted me to be a doctor," said Luke Bunting, twenty-one years old, from Lisburn, in Northern Ireland. After he got to medical school at Manchester University in England, he discovered for himself how right she was. "I couldn't be anything else. I wouldn't find anything else as interesting as learning about the body, how it works, and how to fix it."

He also learned a great deal about how the body can break. In his first year of medical school, he was leaping down some stairs on his way to class when he dislocated his left knee and tore three ligaments. The injury was so bad that he was hospitalized that spring. Just the week before, he

"JUST DOING IT WAS LIKE CLIMBING EVEREST TO ME."

had met a fellow medical student from England, Emily Porter. "I couldn't have made it through that time without Em," Luke said. "I think that was really what got us together."

The relationship got better and better, but the knee got worse. Fourteen months later, on the eve of his second-year final exams, Luke underwent surgery to repair an anterior cruciate ligament, replacing it with a piece of his hamstring. When he awoke from the general anesthesia, he began chewing codeine pills to dull the pain while he studied. Two days after his last exam, still hobbling and uncertain if he had passed his courses, Luke flew to America with Emily to work on the boardwalk in Wildwood, New Jersey, for the summer.

Luke and Emily were in love. They wanted to spend the summer together, they wanted to see America, and they wanted to meet people from all over the world. Virtually everyone who operates the midway rides and games along the boardwalk is a foreign student—from Eastern Europe and South Africa and Russia. Luke and Emily worked fifty-five hours a week, with just one day off, for just six dollars an hour. He sold tickets from a booth; she operated a water slide.

At first, Luke could barely walk, and wished he'd brought his crutches. But he stretched and strengthened the knee daily, and slowly, gradually, cut back on the painkillers. He remembers the first day he could actually jog and kick a soccer ball without pain.

He had nearly lost hope that he'd be able to do either again. Also in July, he and Emily got word they had passed their exams—a great relief and joy.

In mid-August, as they neared the end of their summer in America, Luke, Emily, and their friend Sinead McCarthy used their day off to visit Philadelphia. Luke had waited all summer, and finally he was ready to run the Rocky Steps. With his knee far from completely healed, he lagged behind Emily and Sinead. But he was so excited at the top—high-fiving the two women—he decided to run them again.

"Coming to America, I didn't think I would be able to run them," said Luke. "Just doing it was like climbing Everest to me."

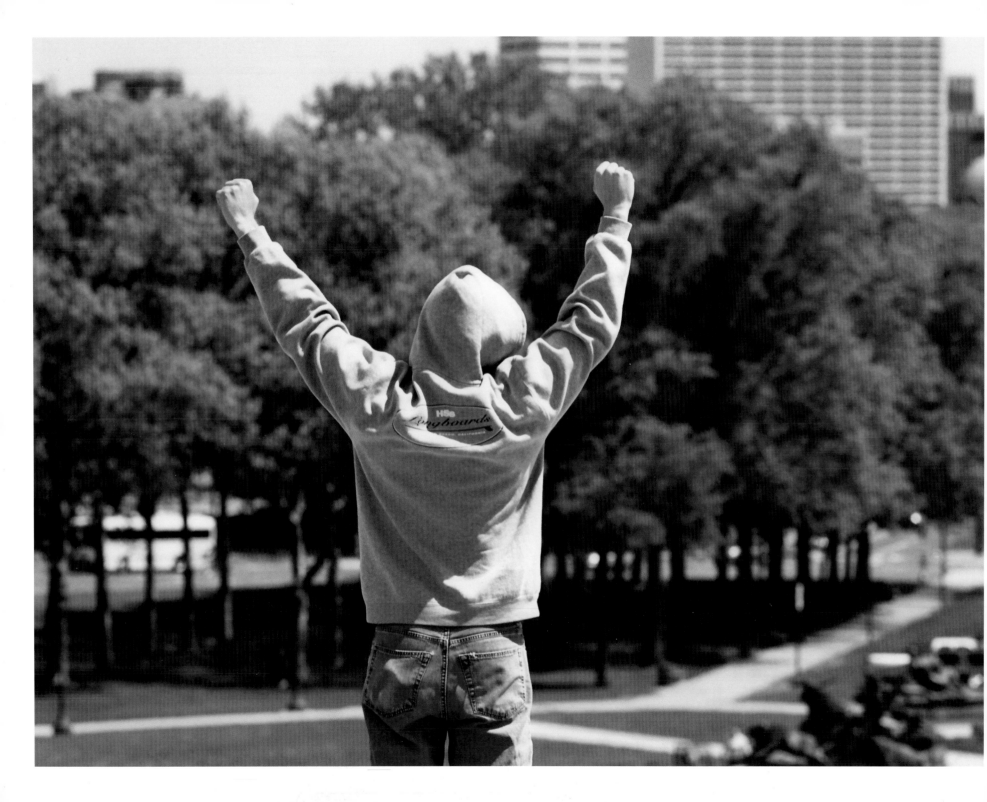

27 SKI BUM

★ I know that envy is a sin, but there were aspects of A. J. Jones's life—the romance of skiing year round, of falling in love with a beautiful ski champion, of fulfilling his dreams—that had me on the verge of envy. He could have sung Sinatra at the top: He did it his way.

A. J. Jones has what I consider the perfect life. It is but a slight exaggeration to say that he was missing only one thing: his *Rocky* moment.

A. J., twenty-five years old, grew up in West Chester, Pennsylvania, in the suburbs of Philadelphia. He attended East Stroudsburg University in Pennsylvania's Pocono Mountains and majored in Commercial Recreation—the emphasis on skiing.

In college, he took a job as a ski instructor at Pennsylvania's Camelback Mountain. He soon moved out to Colorado's Beaver Creek resort, where he teaches skiing half the year. The other half he spends in Australia, as a ski instructor in the Snowy Mountains.

It was there, a few years ago, that he fell in love with Sarah Edwards, twenty-four years old, an Australian ski champion who shared his dream.

"They follow snow around the world," said A. J.'s father, A. Marshall Jones.

"I do what I love everyday," said A. J. "I go to my job, and I love being there."

A. J. said his great challenge, and reward, is getting people to trust him on a mountaintop. "Skiing can be a pretty crazy sport for a lot of people," he said. "Going skiing for them is like going out on a limb. Flying out to Colorado and going on a green circle, like a really flat slope at the top of

"ALL I KNOW ABOUT PHILADELPHIA IS ROCKY CAME HERE AND DANCED ON THE STEPS."

the mountain, that's as far as they've gone in their life, and you have to be able to see that, and do a lesson on that." (In 2004, A. J. was Ski Instructor of the Year at Beaver Creek.)

On a beautiful day in May, A. J. brought Sarah to his hometown. "All I know about Philadelphia is Rocky came here and danced on the steps," she said.

A. J.'s father joined them. He wanted to be there to celebrate his son's *Rocky* moment. "He had to ignore all his relatives and friends attempting to dissuade him from his dream job," Marshall said. "It would have been easier to become a management trainee somewhere."

A. J. spends his life on mountaintops, but he had never been to this one. He pulled up the hood of his gray sweatshirt for effect, and up the Rocky Steps he went.

"I felt like coming out here and doing this was completing something, you know, of my Philadelphia upbringing and heritage," he said. "I had to come out here and do this.

"I think that sometimes I identify with Rocky because I was always wanting to do what I am doing now, but had to overcome so many people telling me that I wasn't going to make it happen. People told me that I could not make a career out of skiing, that I wouldn't have any money and would just be a ski bum.

"Well, I have proved everyone wrong and am living my life the way that I want to, and it's working."

A PHOTOGRAPHER'S VIEW

by Tom Gralish

The work of a daily newspaper photographer can often mean you try to get into and out of a situation with a "usable" picture in the shortest possible time. This kind of picture is about "recording the scene." But if you have the chance to slow down, to watch a scene develop, then you can really zero in on observing, and recording, the life in front of you.

When Mike asked me to join him on his visits to the steps of the art museum, I accepted because I knew we would be able to take our time observing people. There was something special about the Rocky scenes; they unfolded again and again, each with a definite focus on the steps, but each culminating with its own climax: the joyous fist-pumping celebration; the heartfelt exclamation (or proposal); the gaze of fulfillment down the Benjamin Franklin Parkway. Many of the runners had their personal "cinematographer" running alongside with a video or cell-phone camera.

The wide-open steps of the art museum gave us a great view of approaching Rocky runners. Sometimes I felt like the host of a TV nature

show, observing my subjects, trying to anticipate what each person would do, without letting them know that they were being watched. (Were they just museum-goers? Were they there for a view of the skyline? Would they run? Two steps at a time? "Rocky" at the top?) I knew the book would work only if my photos—and Mike's observations—were completely candid, so I had to be ready for anything. We never entered a scene until we felt it had come to a close and we could talk to the runners without altering the experience.

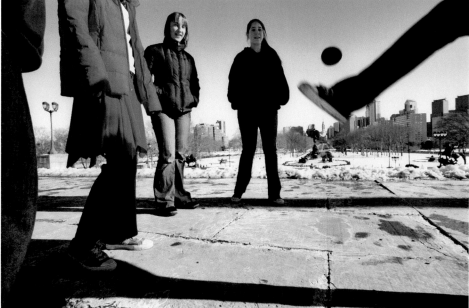

The steps give everyone a lot of personal space, and I often had to work hard to position myself for the best shot. I needed to be unobtrusive, so that runners wouldn't become self-conscious—or I might stifle their inner "Rocky"—but I wanted to be close enough to capture the intimacy of the "moment," whenever it happened.

I loved photographing runners when they were most being themselves. Sometimes, that was when they were emulating Sylvester Stallone. But I tried to stay alert to the opportunity to capture them at other times, too—I wanted a book filled with more than just images of people thrusting their fists into the air. One of the challenges, and rewards, of spending so much time on this project was to stay vigilant and observant, looking for shots that would give a complete picture of life at the Rocky Steps and the runners' experiences there. I hope my photographs convey that overall picture and show the Rocky runners' winning combination of seriousness and playfulness. ★

SUMMER

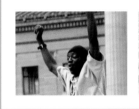

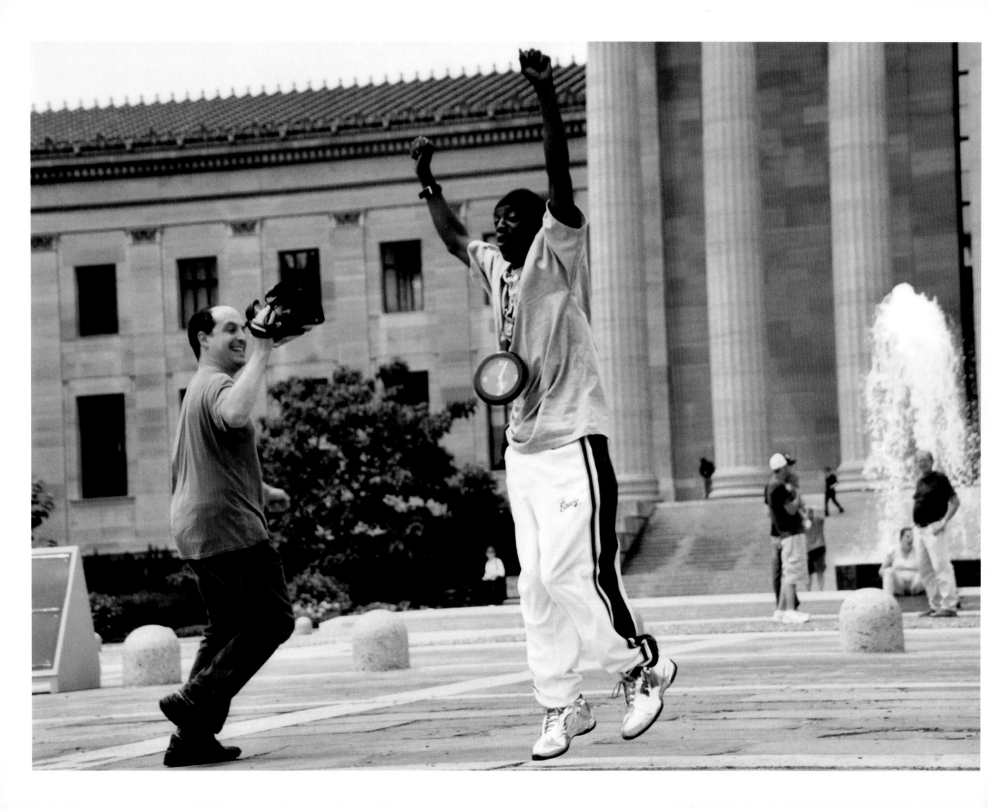

28 FLAVOR FLAV

★ I must confess, I didn't know who Flavor Flav was. But so many others at the steps did, that I could tell immediately we had a celebrity in our midst. Flav epitomized for me the immense and crushing power of American pop culture. But the Rocky Steps symbolize that one is never beaten. A person can always reinvent himself—even a man who already wears dangling on his chest a clock the size of a Frisbee.

"FLAV IS THE HORATIO ALGER STORY REVISITED."

Flavor Flav was once world-famous, maybe even more famous in some circles than Rocky. He is a member of Public Enemy, the pioneering, and the most influential, hip-hop group of all time. The *New York Times* called Public Enemy "the Black Panthers of the hip-hop generation." In the late 1980s and early 1990s, their albums sold millions of copies. His partner, Chuck D, would spew the militant message—the dense, dark call to action—then Flavor Flav would leaven it with comic relief.

"He would look like a clown, doing this thing that looked comical, but he'd also be lifting the conversation himself," said Tom Moon, former rock critic for the *Philadelphia Inquirer*. "A lot of people 'got' Public Enemy because of Flav."

Flavor Flav was raised in poverty and rode the "Flavor Wave" to affluence and fame. Then his own failings—allegations of drugs, guns, abuse—cost him in so many ways and landed him briefly in jail. By 2004, though still performing, he was on the periphery of pop culture.

But Flav didn't fade away. F. Scott Fitzgerald wrote, "There are no second acts in American lives," but that was long before the creation of reality TV. In the fall of 2004, Flav appeared on the VH1 reality show, *The Surreal Life*. The season premiere was the most-watched show in VH1 history. For the twelve days of filming, Flav lived in a Hollywood mansion with five other used-to-be stars. One of them was the actress Brigitte Nielsen, a six-foot, two-inch Nordic blonde—and former wife of Sylvester Stallone—who had costarred in *Rocky IV*. One night during filming, Flavor Flav and the former Mrs. Stallone hooked up. In fact, love blossomed so strongly that VH1 created a new reality show just for the two of them and called it *Strange Love*.

His connection with Brigitte Nielsen brought Flav to the Rocky Steps one hot Saturday in July. He was in town with Public Enemy for a performance. Flav had a film crew of his own with him that day. David Hausen, a documentary filmmaker, was working on a movie about Flav's life. A great fan of the camera work in *Rocky*, Hausen suggested that Flavor Flav run the art museum steps.

Flavor Flav said he had seen only one *Rocky* movie, and he couldn't remember which. He also had no idea of how to run the steps properly or how to "rocky" at the top. After one fairly listless attempt by Flav, David Hausen coached him. Then Flavor Flav ran the top seven steps again, this time releasing a passionate inner Rocky on the plaza at the top.

Flav certainly appreciated the connection between running the Rocky Steps and being involved with Sylvester Stallone's ex-wife. "I run up here for my girl, Brigitte," Flav told the filmmaker's camera. "She made me feel like this. Love you, Brig. Need to know that."

Flav had a mouthful of gold teeth and gold rings on his fingers. He wore what he called "Da Da Supreme" chrome sneakers, as shiny as car bumpers. Hanging around his neck was a clock bigger than a salad plate. That is his signature piece.

The reality shows helped resurrect Flav's career. He is working on a new album and planning a comeback. "Flav is the Horatio Alger story revisited," said David Hausen, "a guy that has risen from the bottom to the top. And he's going to rise again."

29 THE FIGHTER

★ I could feel how hard this woman's life had been, yet she had such a sparkle, such a spirit. She had endured a lot, and here she was on a weekend getaway with her daughter. What could be more fun? Being with her made me happy.

Gale Lewis grew up poor in Port Arthur, Ontario. She was one of thirteen children. "It was a lot of kids, little food, and no money," she recalled. She got married while still a teenager, but after the man began to beat her, she was smart enough, brave enough, to eventually divorce him. Her mother died when she was twenty-seven.

Then life dealt her a better hand. She met and married Jim Lewis—as good as a man can be—and moved to Kelowna, a small town in British Columbia. Their daughter, Christy, was born in 1976, the same year that *Rocky* was released. Gale always loved that movie. She could relate to Rocky's struggle.

Ten years ago, Jim was diagnosed with colorectal cancer. "He had his last rites," Gale recalled. "They told me he wasn't going to survive the night. But you know what? I prayed and prayed and prayed. You pray like in *Rocky*. I said, 'Take everything we have, but don't take him.' And that's what happened. We lost everything we had. But he survived.

"He was so ill for so long," she continued, "and I had to help take care of him. I couldn't work and take care of him, so we had to sell our house and everything we had that was valuable. But we had each other. And that's what it's all about." For the last seven years, she and Jim have lived in a thirty-foot RV. He's disabled, but together this couple perseveres.

"It's like *Rocky*," said Gale. "There's so much tragedy. You have to fight your way through it. It's all about how much fight you have in you, how much drive."

"THAT'S HOW I FELT AT THE TOP...JUST LIKE ADRIAN."

Meanwhile, Christy grew up into a beautiful woman, a nurse. For most of her twenties, she worked in a Calgary hospital. But at the age of twenty-nine, she took a temporary nursing job at Albert Einstein Medical Center in Philadelphia.

Rocky wasn't the reason she moved to Philadelphia. "Shopping, really," said Christy. "And the men."

About that time, Gale's sister died. Two months later, another sister suffered a brain aneurysm and lapsed into a coma. In June, because Gale needed and deserved a treat, Christy flew her mother to Philadelphia. "She dedicated a whole week to taking me away from all the pain," said Gale. When Gale first heard about the trip, she told Christy over the telephone, "I want to run up the stairs that Rocky ran."

That's the first place Christy took her mom. Gale, at age sixty-one, blasted up the steps. She was jubilant, astonished at how emotional she felt. "I always wanted to do that. I never thought I would, ever. It was amazing. What a thing to take back home. It was unbelievable. I was waiting for the cameras and applause. It's hard to really explain. It's like an overwhelming feeling."

After a few days of reflection, Gale elaborated: "You know, in the movie, when he was screaming for her and she was pushing through the crowd to get to him? That's what it was. That's how I felt at the top of the stairs, just like Adrian when she finally reached Rocky in the movie, at the end of the fight. You feel it all in one moment."

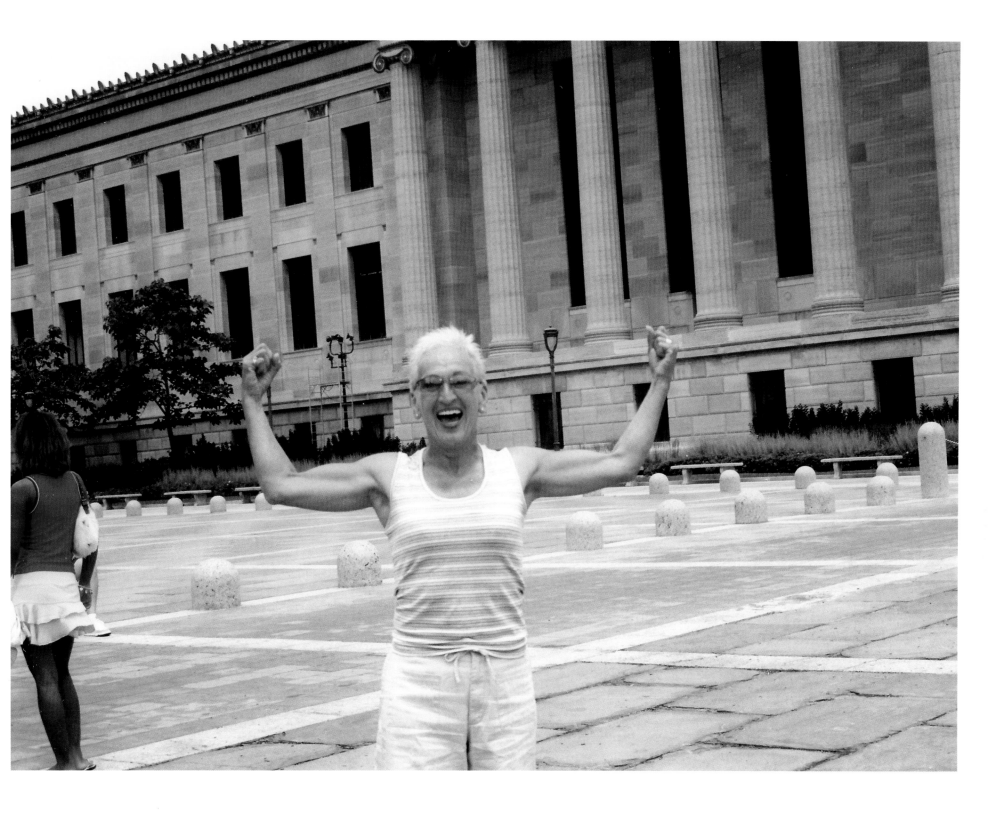

30 SHE IS HIS ADRIAN

★ Irem and Gino had both come a long way in life. She was more a believer in the Rocky Steps as a symbol. It took him a while to realize that running the steps isn't about Stallone. This was a moment to shine, to revel in the pursuit and fulfillment of his own dream, and that only became clear to him the closer he got to the top.

When Irem Bacak was ten years old, she passed the entrance exam to attend the top public school in Turkey. Then she studied hard to get into Bosphorus University in Istanbul. While there, she worked full-time to support herself. Her dream was to attend the Wharton School of Business at the University of Pennsylvania in Philadelphia.

She took the GMAT—the entrance test for American graduate business schools—three times. Her mother urged her to keep studying and retaking it to improve her score. The third time, Irem scored 710 out of 800. "When I saw the result, tears came to my eyes," she recalled. "It was my *Rocky* moment. I called my mom immediately."

She wrote her application essays, gave them to professors to edit, and rewrote them. "It was really like Rocky's training," she said. Finally, she was accepted. "At first I didn't believe it. I didn't cry because I was in shock."

When Irem arrived in Philadelphia in 1999, one of the first things she did was to run the Rocky Steps. "Turkish people are dreamers and risk-takers," Irem said. "They share the same dreams as many Americans—to build a better life for themselves and their families." In Turkey, she said, the gap between rich and poor is much wider. "Because in their daily lives there is a lot of struggle, movies that show the success of underdogs are very popular in Turkey."

After graduating from Wharton, Irem took a job near San Francisco as a marketing manager for a software company. She was successful, but lonely, so she put a posting on Yahoo! Personals. That's how she met Gino Radzik.

Growing up in Chicago, Gino explained, he was allergic to "almost anything a human can eat, breathe, or touch." He was a poster boy (literally) for the Chicago Lung Association. Gino's parents discouraged him from

playing any sports, to minimize the strain on his lungs. As a result, he was overweight. But Gino loved playing saxophone, and also taking apart VCRs, tape recorders, any and all audio equipment.

He dreamed of leaving Chicago to head west and find a job as an audio engineer for a technology company. He made his dream come true when he moved to the Bay Area to start work for such a company. In the process, he turned his life around. He began to cycle, run, and snowboard; he lost fifty pounds. His allergies diminished. And he found Irem on the Internet.

"Irem is an example of a woman who has gone against great odds to leave her family, her country, and the customs of her culture to pursue her dreams," said Gino.

"She is an incredible, loving person, and inspires me to better myself and get the

"I THINK IT GIVES ME HOPE, COMING HERE."

most out of my own life. She is my Adrian."

In June, six months after they met, Gino and Irem flew to Pittsburgh to attend a wedding. Then they drove the five hours to Philadelphia, where Irem wanted Gino to run the Rocky Steps. "I think it gives me hope, coming here," she said. "Actually, it does. You need to believe in yourself. Don't give up. Anything is possible."

Gino began his run up the steps in jest. But his attitude changed as he climbed higher. He was reflecting on his own life, and he "rockied," with gusto, at the top. "After mounting the last step," he said, "I felt that I, too, was on top for a reason. Perseverance and the continual pursuit of my dreams are special, and something to address every day of life. This is a perfect opportunity to celebrate victories in our lives."

Then Irem and Gino, arm-in-arm, walked back down the steps.

31 ROCKY, JR.

★ When I saw Philip Baldino run, I thought to myself, "That's the power of myth." Rocky has so penetrated our psyches that this five-year-old had embraced it, red boxing gloves and all. Maybe he'll be back here in sixty or seventy years with his grandson. Anything is possible at the Rocky Steps.

At the age of five, Philip Baldino is already a *Rocky* fanatic. His adoration is something the boy's father, Joe Baldino, encourages. He thinks Rocky is a great role model. "I've been promising to take him here for I don't know how long," said Joe, standing on the Rocky Steps one hot Saturday in August. The Baldinos live in South Philadelphia, near the sports complex, near the Rocky statue, and they often go to see it. But Philip wanted to run the steps, and now he finally had his chance. He ran them wearing big red boxing gloves. He paused halfway up, thrusting the gloves high into the air, so his dad could take photos.

At the top, father and son sparred, just like pros. "Jab, jab," Joe encouraged, holding out his hands, Philip swinging away. "Side-to-side," the dad prodded. "Side-to-side, that's it, side-to-side. Jab, jab." Joe's cigarette was just about out. "All right," he announced, "that's the round."

A professional skateboarder was also at the steps, filming a video—he ran to the top carrying his skateboard, threw it down, jumped on, and did a 360-degree kick-flip. The skateboarder, nineteen years old, was so impressed with Little Rocky that he asked the boy to give him a punch. Philip KO'd the skateboarder. When that was done, Dad continued, "OK, let's get 'em up. Another round."

Earlier in the summer, father and son had visited several area malls looking for Rocky paraphernalia, but couldn't find any. So they searched the Internet and downloaded some stills from the *Rocky* movies. They brought the pictures to the boardwalk in Wildwood, New Jersey, where they were made into iron-on decals. Then they ironed the

"I RUN FASTER WITHOUT THE GLOVES."

decals onto Philip's pillowcase. Now, when he sleeps at night, Philip lays his head upon the greatest *Rocky* scenes. His room, says his father, is covered with *Rocky* posters.

The boy's favorite line from *Rocky* occurs when Adrian is alone in Rocky's apartment for the first time. She's nervous and she wants to call her brother, Paulie, who, she says, might be worried about her. Rocky has no telephone, so he throws open the window and yells out into the night, "Yo, Paulie, your sister's with me. I'll call youse back later. See ya." Philip thinks that's hilarious.

In some ways, Joe Baldino is a lot like the character his son adores. He grew up in South Philadelphia and lives three blocks from where he was raised. "I never left the zip code," he says. Like Rocky, Joe Baldino came up the hard way. "I had nothing given to me," said Joe. "In all honesty, I was a kid when my father died. I was twelve. I basically worked all my life. I didn't go to college. I always had two jobs, always a hard worker. I started with the railroad right out of high school, and I moved up the ladder, and I'm a director today. I started out as a train caller. I was eighteen years old."

Philip "wants a speed bag for Christmas, but I'm trying to find a place in the house to put it," said his father. "He's got a punching bag that pops back up, and he hits that all the time. Who knows? Maybe he will be the next Rocky. You never know." In reality, of course, Joe Baldino would much prefer that his son go to college and get an education.

Before leaving, Philip wanted to make one last run up the Rocky Steps. This time, however, he removed his boxing gloves. "I run faster without the gloves," he told his dad. And off he went.

32 HE CARRIED HER PURSE

★ Our contact at the steps was quick, a few minutes. But our relationship continued for months afterward, via email. Many Rocky runners seemed to be energized by the idea of my book, by my questions. Our conversations prompted Diane to review her life, to write her story at great length, to take stock of her own journey.

Diane and Dave Hathaway are from Cincinnati and have been married for thirty-seven years. She was the one who wanted to visit Philadelphia over the Fourth of July weekend. After three days of nonstop sightseeing, however, she was exhausted, too tired to run the Rocky Steps, but he insisted. So they both ran—and he carried her purse.

Diane was breathing hard at the top. "If you hadn't carried my purse," she said to Dave, "I never would have made it."

That was just perfect because, in a sense, all through their married lives, he has carried her purse. Dave has encouraged Diane when the odds appeared to be against them, given her support when quitting might have seemed easier. She was often the dreamer, the inspiration, the person with the big ideas. He helped make those dreams come true.

On their first date, in 1967, she told him she wanted to go to law school—rare for a woman at that time—and he encouraged her. In fact, they went together, beginning in 1969. She was just one of five women in a class of two hundred at Ohio State University. On the first day of class, her contracts professor said to her, "Mrs. Hathaway, you have exactly one year to justify to me that you deserve the seat that should rightfully have gone to a *man*." She graduated cum laude.

They tried selling encyclopedias door-to-door when money was tight during law school. Then she started working part-time as a legal secretary. She was going to drop out and work full-time to support him, but he refused. They borrowed money and stayed in school.

After graduation, she had a dream of applying for a clerkship with a federal judge—a plum job, extremely hard to get. He encouraged her and agreed to follow her wherever she landed a job. She clerked for Judge Peter T. Fay in Miami; it was a rich and rewarding experience.

Dave was there for Diane all along life's path. When she told him she never wanted to have children, he was patient. When she miscarried twin boys, he shared her grief. When their two children were born, he suggested they move back to Cincinnati, where she reveled in motherhood. She was among the first of the new generation of women determined to have both a career and a family. She worked as a corporate attorney and served as a PTA room mother. She drove her kids to ballet and baseball.

But she paid a price for trying to do it all—with a heart attack when she was still in her early forties. Dave supported her in 1987 when she moved into academia, teaching law to undergraduates at the University of Cincinnati College of Business, what Dave considers "her true calling." All this time, Dave was a practicing attorney.

He was not going to let her leave Philadelphia without running the Rocky Steps. "The fact that I was there to carry her purse was very symbolic," said Dave. "She dreamed the dream and climbed the mountain. I was there to facilitate the climb and to share in the result."

Diane thought about her accomplishments as she ran. "To me, each step seemed like revisiting an old friend, an acquaintance, an experience, a challenge met, a sorrow survived," she recalled. "It was the last step that shall remain seared in my mind's eye, however. I consciously paused before I took it, knowing that, in my mind, that would be confirmation of my life."

"EACH STEP SEEMED LIKE REVISITING AN OLD FRIEND."

33 A MAN OF THE WORLD

★ Many times, I couldn't get their life stories at the steps. I might capture the Rocky moment, but I wanted to learn much more about them, because only when I did, would the power and resonance of their moment become clear. It often required a series of follow-up emails to get the whole story. The thing I loved most about Roy Simon was the story of his religious conversion. What a world!

He has a generous girth—a sign of his success—and gray in his goatee, which is a sign of his fifty-three years. His own son describes him as "a lazy guy." But Roy Simon, who lives in the port city of Cochin, India, and who never runs a step at home, galloped up the seventy-two Rocky Steps—without speed, but also without any doubt that he would finish. "The spirit was in me," he said. "That's why I run."

He had visited Niagara Falls, Los Angeles, and New York City. He had seen his oldest son graduate with an MBA from the University of Michigan. Yet while he stood on the plaza of the Philadelphia Museum of Art, smiling and panting, he said that running the steps was the highlight of his trip to America. "Yes, seriously, I'm not kidding," he said. "I'm coming from my heart."

"When you think back, it correlates," he explained. "Your coming up in life, and the way you are now."

"He's lived a tough life. Nothing's come easy," said his son Anish, "so he has a lot to relate to in the movie."

Roy had seen all five of the *Rocky* movies, but not for years. He didn't even realize he was coming to the Rocky Steps until moments before he arrived. His sister lives in the suburbs of Philadelphia, and as part of his visit to America, he stopped to see her for a few days. Anish had the idea to come to the museum steps. He has two younger brothers at home who are big *Rocky* fans. He knew they would get a kick out of seeing their father running as Rocky. But when Roy realized where he was, what he was about to do,

"HE HAS A LOT TO RELATE TO IN THE MOVIE."

he felt the hairs on the back of his neck rise with excitement.

He wasn't celebrating Rocky's life; he was using the steps to celebrate his own.

He had started at the bottom in life, as a clerk for a shipping company. He left his home in southern India to move to the Middle East because opportunities were better. "I was the only son for my parents," he said. "I had to send money back home to India to support my family. That's the reason I came into the Middle East, so I could earn some tax-free money. It took almost fourteen years. That's a long way, but I could go up the ladder to general manager of a shipping company."

Only when he was financially secure did he agree to the marriage his parents had arranged for him. He and his new bride, Leelu, settled in Dubai, in the United

Arab Emirates, and started a family. Roy soon quit his job to start his own company, Valiant Shipping. There had been rough going in the early years, but now it was successful enough that he could spend two months in America and not worry too much about the business.

At age twenty-six, Roy had accepted Jesus into his life, dunking his head in the Arabian Sea—an Indian man accepting a Christian Savior in the middle of the Muslim world. And in the midst of it all, still a *Rocky* fan.

"I was thinking back," Roy said, "how he dreamed himself, he proved himself, he fulfilled himself spiritually, and with the power of satisfaction he was there enjoying himself. And the same thing happened to me. That inspiration came into me." And it carried him up the steps.

34 THE MEAT POUNDER

★ There have been newspapermen to whom criminals have confessed, or in whom world leaders have confided. I take a certain pride in obtaining Orell's confession at the top of the Rocky Steps. How many reporters could get a man to reveal such a secret?

Orell C. Anderson is forty-five years old, lives in a million-dollar home in California, has a wife and three children, and earns $325 an hour as a real estate damages economist. At the top of the Rocky Steps, Orell made this startling confession: "I go into meat freezers and pound the meat. Not anymore, but I used to."

He had never told this to anyone before, not even his family. As a teenager, he was inspired to sneak into freezers and pound meat after seeing Sylvester Stallone do it in *Rocky*. He felt good finally sharing the truth. "I am now officially out of the closet."

Until he was about thirty (Rocky Balboa's age in the movie), Orell struggled to find himself. He was a sculptor. "I was very depressed and alone at that time, living on a sub-poverty-level income. I chose to leave my struggling life as a full-time sculptor in order to marry, buy a house, and have a family."

He started at the bottom, with not much education or experience, in the field of real estate damage consulting. It is an unusual profession. Orell's job entails determining how much value a property loses after something terrible occurs there. He helped calculate, for instance, that the home of JonBenet Ramsey lost 25 percent of its value after her murder, and that the Heaven's Gate mansion lost 50 percent of its value after the mass suicide there. Nicole Brown Simpson's home lost market value, too, but a confidentiality agreement prevents Orell from disclosing the amount.

He often testifies at trials. When I asked how he got into this line of work, he responded, "Think about what you did in junior high, and what you would write on—like

cannibalism and Jeffrey Dahmer. So, it's like I still get to do that. I get to go there."

Orell came to Philadelphia in June for a convention of people in his line of work. Not all of them do crime scenes. Some deal with more mundane legal questions, such as the value of easements or cases of eminent domain. One evening, he was in a hospitality suite on a top floor of his hotel with fellow conventioneer, Steven L. Castellano, looking down the Benjamin Franklin Parkway to the Rocky Steps.

Steve, forty years old, from Pleasant Hills, California, has been a *Rocky* fan all his life. Back in high school, getting out of bed for morning football practice, *Rocky* was his motivation. He'd crank up the music to get

"YOU GET UP HERE AND THERE'S THAT TWINGE OF...JE NE SAIS QUOI."

in the mood for practice.

All week, the two men had talked about doing it, so they grabbed a cab. At the base of the steps, they hopped out and took off running.

At the top, Steve couldn't quite unleash his inner Rocky. Orell, though, let it all hang out. He really hadn't intended to, but he couldn't help it. "You get up here, and there's that twinge of 'who knows what'—*je ne sais quoi*. I felt it, like, coming up my neck. I'm getting a little too spiritual here. It was an epiphany."

Afterward, when the two men went off to dinner with other conventioneers, they talked all night about their run up the steps. Though Orell and Steve attend conventions year-in and year-out, this one they would remember.

35 MOVIE NIGHT

★ It is rare, even thirty years after its release, to find some-one in Philadelphia who has never seen *Rocky*. Meeting Lauren Campbell gave me the chance to watch the movie again as if for the first time. Lauren embraced the spirit of the moment. She will always remember where she first saw *Rocky*, and we will share that small, special bond.

Lauren Campbell and her friend Amanda Graves came early and ate sushi on the steps. Not exactly a Rocky meal (that would be five raw eggs in a glass), but the two women were new to the ways of *Rocky* and Philadelphia. They joined hundreds of others—virtually all of them *Rocky* fans—on the steps of the Philadelphia Museum of Art on a Sunday evening in late June to watch *Rocky* on a huge outdoor screen.

Neither of these twenty-five-year-old women had ever seen the movie. "We thought this was the perfect time and place to see it," said Lauren.

Lauren grew up in Virginia, went to Oberlin College in Ohio, and moved to Philadelphia in the fall to teach English at one of the city's many Quaker-affili-ated schools. She lives in the Art Museum neighborhood, and she actually runs the steps a few times a week to stay in shape. "Every

time, it hurts like hell, and I want to lie down when I get to the top—but it's healthy."

She often sees others celebrating like Rocky at the top, but she nev-er quite understood the gesture or considered doing it herself.

On this evening, Lauren was feeling more like Rocky than she could have anticipated. She had lost her job on Friday—her posi-tion had been eliminated—and she was searching for courage.

"My dream is to either direct plays or conduct choirs, and use the arts somehow to promote com-munity development and social change," she explained. But such a career choice is much more dif-ficult and less stable than teach-ing English. "I have been afraid to pursue the arts," she said, "but I know I won't respect myself if I don't at least try."

The crowd on the steps had swelled, and when the movie start-ed, the audience roared. "Makes me want to see it more," Lauren

whispered to Amanda, "that all these people love it."

After college, Lauren spent a year in South Africa. She learned to speak Xhosa, a language with a "click" in it. When she says certain words, like "Xhosa," she makes a clicking sound. She was almost certainly the only person on the steps that night who could speak Xhosa. Yet after twenty minutes of watching *Rocky*, she expressed a deep lament: "I wish I could say 'youse' and be realistic."

Lauren couldn't understand why Rocky at first rejected the offer of a shot at the heavyweight title, the opportunity of a lifetime. She didn't know that all great heroes reject the first call. They're scared. They doubt themselves. (Witness her own reluctance to pursue her life's dream.)

When the crescendo came

SHE ACTUALLY RUNS THE STEPS A FEW TIMES A WEEK TO STAY IN SHAPE.

in the movie, as Rocky ran the art museum steps, Lauren did not raise her arms as he did. She just cheered wildly and looked around at everybody else cheering wildly. Many in the crowd did stand and "rocky" in place.

In the last scene, as Rocky screamed for Adrian, and they hugged and confessed their love for one another, Lauren's eyes misted. As the credits rolled, and the crowd cheered, she stood up and declared "That's an awesome movie.

"He knew it mattered more that he challenged himself than that he won," she explained. "I loved that he celebrated on the steps, alone, before he even fought."

Lauren still does not plan to "rocky" when she runs the steps, "unless it's maybe 4 A.M.," she said. "His moment of celebration was so cool because it was just for himself."

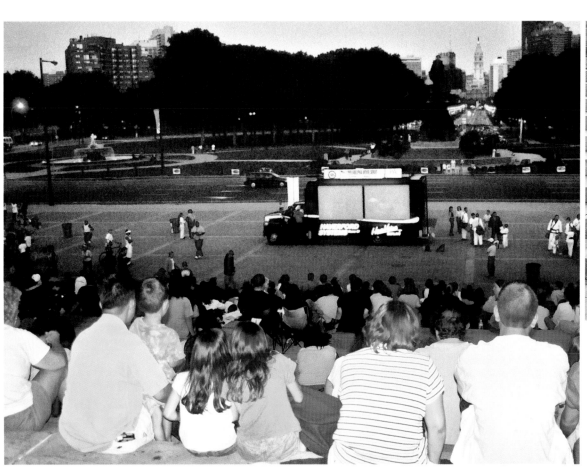

36 MOVIE NIGHT II

★ Lots of different things drew me to talk to particular runners. With Diyan Cholakov, the choice was obvious. At the annual outdoor screening of *Rocky* at the museum steps, the last three people to leave, out of hundreds who had come to watch, were Diyan and his two friends. After midnight, they were still standing at the top of steps, "rockying."

Diyan Cholakov wears a tattoo on his left arm that reads, "Hold my own." His parents back home in Bulgaria tried to talk him out of it, but Diyan is already thinking of his next one, on his other arm. It will read, "Loyalty."

Twenty-four-year-old Diyan is a student at the University of Shumen, his hometown, pursuing a degree in juvenile social work. But he knows a degree will do him little good in Bulgaria. "If you have a higher education in Bulgaria, you will be unemployed," he said. "There is more unemployment right now, no matter if you get higher education, or second higher education. Like my sister—she has two higher educations, but she's working as a shop assistant."

Diyan paid an agency two thousand dollars, a year of savings, to bring him to America in late spring and find a job for him. He works seven days a week at a roof-top swimming pool, thirty floors above Center City Philadelphia. Mostly, he is alone. Few people come to the pool during the day; they are too busy working. He relaxes, listens to hip-hop music, thinks about his life, and talks on the telephone to other Bulgarian lifeguards at other pools. He cannot afford the bars or the nightlife of the city. Many nights, after work, he walks over to the art museum steps and runs to the top, where he celebrates like Rocky.

"I love *Rocky*," said Diyan. "When I was a young guy, I saw *Rocky* all the time. *Rocky* is still on my mind—I can't explain. I can't speak too well. I can't explain. But he stay on my mind for many years. I'm always reminding of this movie. Rocky was following his target to be a champion. He's on his

"THAT'S WHY I LIKE ROCKY, BECAUSE HE'S FOLLOWING HIS TARGET."

own. He was hardworking, same like us. He has to work dirty job because he ain't got no money."

On "movie night" in late June, Diyan sat on the museum steps, along with hundreds of other fans (including Lauren Campbell and Amanda Graves), and watched the annual outdoor showing of *Rocky*. Together with two other Bulgarian lifeguards he has met in Philadelphia, he stayed long after the movie was over. In fact, the three of them were the last to leave the steps that night, just hanging around at the top enjoying a beautiful evening, occasionally "rockying," until well after midnight.

They simply couldn't believe their good fortune, to have seen this classic movie in this classic setting, and for free.

"Everyone told me don't come back to Bulgaria," Diyan said. "All my friends, because it is bad. Everyone is stealing. I can't explain. People are bad. If I stayed here without papers, I will be an outlaw. I don't want to stay like outlaw. I want to stay with all legal papers." He has no idea how to make this happen. He believes the only way for him to stay legally is to marry an American, and that's not part of his plan. He has a definite preference for Bulgarian girls. "Bulgarian girls are most beautiful in the world." He said this not as a boast, but as a fact.

He expects to stay in America until the end of October, hoping to find another job for a couple months after the pool closes for the season. He'd like to return to America again, maybe attend an American university. "Everyone wants to live better. That's the way of the world," he said. "You want to get better. This is human...human nature. *Rocky* gives me a motivation to choose the right way. That's why I like Rocky, because he's following his target."

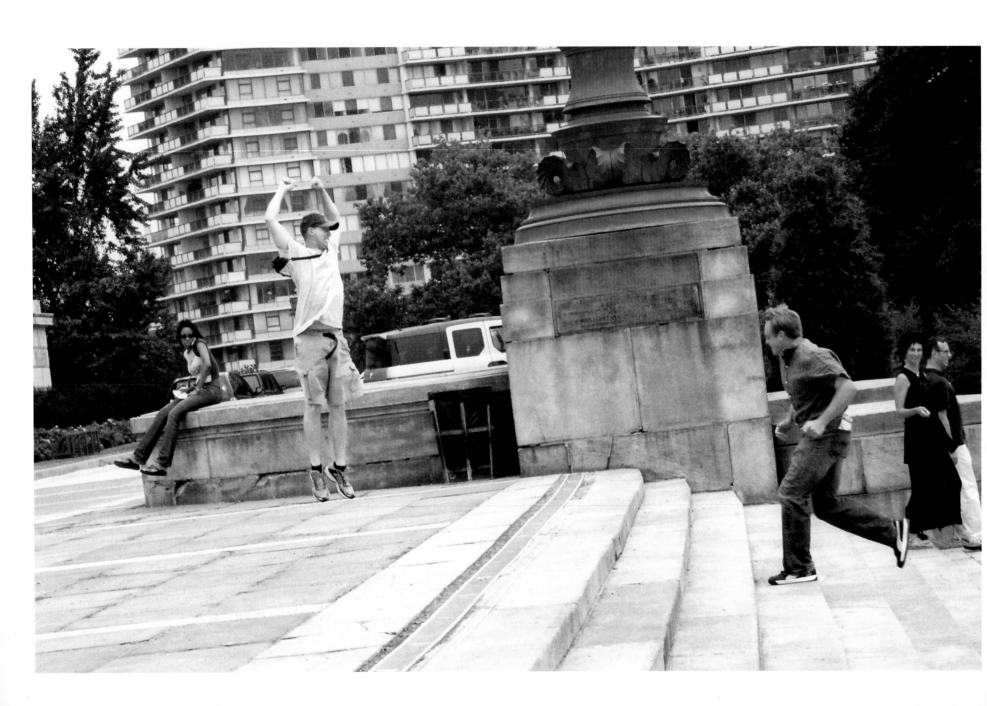

37 THE MEANING OF ART

★ Often, the challenge for me was to figure out what the story was—understanding why someone ran or what it meant to them, even when they weren't sure themselves. I can't say the search was always successful, but I was constantly looking for the *Rocky* core. In Ryan Foran's case, he was upset not to find the Rocky statue at the steps, and that led to a discussion of the meaning of art. You could write a book.

It was during lunch that Ryan Foran suggested that they run the steps. There were twelve of them, all in Philadelphia for a wedding. Some stayed behind, too embarrassed. Not Ryan. He wanted to feel the *Rocky* spirit. But most of all, he wanted to see the statue.

When the group reached the art museum steps, Ryan was the first to take off. "I started with single steps," he explained, "then I expanded to double, and pretty soon it occurred to me that Rocky just let it fly, so I was going by the fours, by as many steps as I could. I had a late surge."

Reaching the top, the tall, lean, athletic thirty-year-old jumped in the air and threw his arms skyward. Then he looked around, and his smile turned to mayonnaise.

"I had heard a rumor that the statue wasn't here," said Ryan, who lives in Chicago, "but I kind of wanted not to believe it."

Many runners expect to see the eight-foot-six-inch bronze statue of Rocky, boxing gloves raised to the sky, standing on the plaza at the top. In the movie *Rocky III*, the city of Philadelphia honors Rocky with the statue and places it at the top of the museum steps. In the movie, the fictional mayor vows the statue "will stand always as a celebration to the indomitable spirit of man." In real life, the populace, even the mayor of Philadelphia, wanted the statue to stay put. Art museum officials and the Fairmount Park Commission (which has jurisdiction over the Rocky Steps) however, felt the statue was out of character and scale with the building's architecture. Rocky's statue was, after all, a movie prop, and didn't belong outside a museum filled with art treasures.

The statue was relocated to South Philadelphia, placed in front of the Spectrum sports arena, the venue where Rocky fights Apollo Creed in the original film's climax.

That just didn't seem right to Ryan. "*Rocky* was a depiction of one man's struggle to achieve," he said, "when all of the odds were against him. How many pieces of art inside any museum can truly inspire its viewers to achieve something against all odds?"

Ryan had just quit a job in technology sales, deciding to stop chasing that "killer payday," which would have allowed him to retire young. He was looking for a job with more meaning.

"I'm currently unemployed and have been looking for a job," said Ryan, "and I'd be lying if I said that *Rocky* didn't remind me that I can accomplish anything in life with focus, hard work, dedication, and determination."

Ryan's friend Yuki Murata ran with him. The daughter of two artists, Yuki studied architecture at Yale University and was starting her own design company in Santa Fe, New Mexico. She, too, couldn't believe the statue was gone.

"I totally appreciate the art museum for its art museum-ness, and I come from a family of a lot of artists," said Yuki. "But I do think, for one thing, art is so much about popular culture. So to discredit the film, and it's effect on pop culture, is something that I think is actually kind of very interesting for an art museum to do, by saying they don't want it. You know? That's what art has always been, sort of a voice of the people. I think it's interesting that the art museum, which is supposed to be an open-minded, liberal institution, is actually sort of not being open-minded and liberal."

Later, after more reflection, Yuki added that the statue's absence "left me feeling as though whimsy and fantasy had been abandoned for the sake of nothing gained."

"HOW MANY PIECES OF ART…CAN TRULY INSPIRE ITS VIEWERS TO ACHIEVE SOMETHING AGAINST ALL ODDS?"

38 ANCHORWOMAN

★ When I saw this attractive young woman, all dressed up, start to run, I felt such achievement, such happiness, exuding from her. People don't normally run the Rocky Steps in cocktail dresses. I expected her story to be a great one, and I was right.

Catherine Andersen ascended the steps in a short blue cocktail dress and sandals with three-inch heels, which revealed her perfectly polished red toenails. She ran slowly and carefully, but with as much fervor as the fastest sprinter.

Rocky had carried her through difficult times.

Catherine, who is twenty-three years old, first dreamed of a career in television news while she was in sixth grade and living outside of Atlanta. She and the school librarian started a video club, and Catherine did the morning announcements. She carried that dream right through Oglethorpe University—where she graduated a semester early, to give herself a head start on finding a job.

"Obviously it's really hard to get anywhere, and you have to start at the bottom and prove yourself and work your way up," she said, "so *Rocky*'s been an inspiration." Her older brother introduced her to *Rocky* when she was eight or nine years old. Later, when he would

come home from college, they'd watch all five *Rocky* movies on video. "It was a tradition."

Catherine landed a job as a news reporter in Grand Junction, Colorado, which she described as "pretty much the smallest television market in America." She did what is known in the business as "one-man-banding," lugging her own camera, shooting her own footage, editing her own reports. The station started her at $6.25 an hour. "I applied for food stamps," she said. But she was elated to get the job, to get a foot in the door.

A year and a half later, however, Catherine was burning out, frustrated with her bosses, desperate to move on to a bigger market. After months of searching, she interviewed with the ABC affiliate in Colorado Springs, a much bigger market. At first, she thought the job was hers, but the news director told her he was considering another candidate. He strung her along for a month; she began to doubt herself. That last week, she turned to *Rocky*—a weeklong movie marathon on TV. "It got me through," she said. "Everyone's

trying to bring you down. So Rocky was my mentor, because no one else built you up."

She felt that her own life was paralleling the movies: Rocky would get pounded by Apollo Creed; her telephone calls would be rebuffed by the news director. "It was just like getting another punch," Catherine said. "It's crazy how profound *Rocky* is," she added, knowing how crazy that sounded. "It gets deeper and deeper, the more I watch it."

Finally, like Rocky, she got smart, got tough. She gave the

news director a deadline and told him she wouldn't call again. Sure enough, he called back and offered her the job. She gave notice in Grand Junction and then flew East to visit her brother in Delaware for a week before starting the new job. They knew they absolutely had to run the Rocky Steps. Catherine dressed up because they were actually going to go into the museum, too.

"I got to the bottom and started running," Catherine said. "It was just something I couldn't help but do."

"IT'S CRAZY

HOW PROFOUND

ROCKY IS."

39 THE POET FROM HUMBLE

★ I've thought a lot about what DeJuan Badger told me. I loved his imagery and passion, and he drew a wonderful analogy between poetry and Rocky. That's not easy to do.

DeJuan J. Badger flew to Philadelphia to participate in a poetry contest. He is twenty-four years old, from Humble, Texas, and his hometown's name describes him well. He doesn't want to be rich or famous. He just hopes that somewhere, someday, somebody will read his poems and be inspired by them to do good.

After reciting his poem in competition, he took a cab to the Philadelphia Museum of Art to celebrate. "This is the first place I wanted to come," he said. "*Rocky*'s my movie. I think about these steps all the time." He wore a baseball cap turned backwards, baggy jeans, and a broad smile on his face. He soared at the top. "For a moment, I felt like Rocky."

He believes Rocky and poetry have much in common. "Poetry transcends the softness of words," he said. "It can be tough, like Rocky's tough. It's kind of symbolic of Rocky's toughness—poetry's endurance in the world of literature."

DeJuan began to write poetry three years ago, when he finally realized "violence wasn't the answer." He had been a hot-tempered young man who loved to fight—and who was good at it, ever since his father gave him a pair of boxing gloves at age seven. "I had all these emotions and stuff, and I didn't know what to do with them. And somebody said, 'You're a writer, so write 'em.' So I just started writing them."

He had always been good with words, but he had never worked at it before. Writing poetry became a journey of discovery and liberation for DeJuan. "In boxing, you know, you express your anger, your feelings, with these," he said, holding up a fist. "The same with poetry. Just un-ball your fist and pick up a pen. Poetry gives you the opportunity to be real. Most times in life, you're acting or putting on a mask. With poetry, you take the mask off and be who you are. No faking. No cool posing. No mask. That's what I like about poetry."

On the steps, he recited a verse from the poem he had written for the contest:

Picking fights I never
could win.
Again and again.
I thought I'd never quit seein'.
But thank God, He came in
myself
When I wasn't strong enough to
come in myself
Nor did I have the strength to
suspend myself
From becoming one of those
foolish young men myself.

DeJuan didn't win the grand prize, but he did win an award for outstanding achievement. Like Rocky Balboa, he didn't take the championship, but he went the distance; he showed himself he had what it takes.

"I just want to do something positive and purposeful with my time," he said. "I don't want my life to be a waste. That's one of my biggest dreams—not to be a waste, not to be a void or empty space."

"I THINK ABOUT

THESE STEPS ALL

THE TIME."

40 THE JAPANESE FAMILY

★ Lots of times, I wished I were multilingual, so I could understand the Japanese and Korean and German and Italian and Israeli tourists, not to mention the Finns, Danes, Bulgarians, and Russians. I saw Kimiko—prim and proper—hurling punches into the air as she spoke rapidly to her wide-eyed children. What was she saying exactly? I'll never know. Her husband explained after the fact. But it's not the same.

Takakazu and Kimiko Hara lived in Philadelphia from the fall of 1990 to the spring of 1992 while Takakazu earned an MBA from the Wharton School of Business at the University of Pennsylvania. Their first child, Takukya, was born here. When they would go out for a walk, their favorite part of the city was the art museum area, and especially the Rocky Steps.

After receiving his MBA, Takakazu returned with his family to Tokyo. He took a job with a shipping company, and Kimiko devoted herself to raising Takukya and his younger sister, Erina, born three years later in Japan. The parents had fond memories of Philadelphia, and after twelve years, they returned to the city for a summer vacation. One of the first places they visited was the art museum steps.

Kimiko, in particular, wanted the children to understand the great American story of *Rocky*.

Her English is rusty, but her husband explained, "On this occasion, my wife would like to explain to our children about the film of *Rocky* and what important lessons we can learn from this film," said Takakazu. "There are a lot of tough times with challenges even in business, when I try to keep self-confidence and to remember that the continuous effort will surely bear fruit," he said. "Another lesson from *Rocky* is that the love and support from family members and friends are another essential part of success and were quite important for Rocky."

In short, Kimiko tried to convey to the children that if they work hard, as Rocky did—even though he was poor, with no advantages in life—they can achieve their dreams and goals. That was the lesson of the steps. The problem was, of course, that neither of the children, now twelve and nine years old, had ever seen the movie or even heard the name Rocky.

Kimiko had sought to keep them relatively sheltered from the violence of American pop culture, and their lives were busy with homework, tennis, and karate. Standing on the steps, Kimiko tried to explain to them that Rocky was a boxer, and this diminutive woman hurled a few punches into the air to illustrate what she was talking about. The children listened earnestly, but they didn't quite get it. All around them on this gorgeous summer afternoon, other people were running up the steps and thrusting their hands in the air, and the children accepted that this was what people did here. But never having

THE CHILDREN ACCEPTED THAT THIS WAS WHAT PEOPLE DID HERE.

seen *Rocky*, they couldn't hope to grasp the meaning of the moment.

Takakazu and Kimiko said that after they returned

to Tokyo in a few days, they intended to rent the video so the children could appreciate where they had been, and begin to comprehend more fully the lessons they were being taught.

41 REV. NELLIE

★ In person, she can speak only with the dazzle of her eyes—and by laboriously pointing her palsied fingers to the letters of the alphabet on a board she carries with her. But in email correspondence, she reveals herself as a spirited woman with strong political views and a wicked sense of humor. Nellie Greene was the most inspiring person I met at the steps.

Writing a sermon takes the Reverend Elinor Greene at least five or six weeks. Just steering her finger toward the correct letter on the keyboard requires all her concentration and effort. Her hands shake so much that she often strikes the wrong key; then she has to travel all the way across the keyboard to hit backspace—and then she tries again. She often doesn't have strength enough to depress a key with one finger, and needs two.

Letter by letter, hour by hour, day by day, she writes. About mercy. About anger. About her favorite passages from the Bible.

Six or seven sermons a year. She doesn't have the breath to blow out a match, much less to speak, so a parishioner—after rehearsing with Reverend Greene—will read the sermon on Sunday morning from the pulpit of the United Methodist Church of Chestnut Hill in Philadelphia.

Nellie, as she is known to friends, is now fifty-two years old. When she graduated from Chatham Hall, a girls' prep school in Virginia, she had earned letters in five different varsity sports, she had been president of the Service Club, and according to a close friend, she "sang like an angel." Nellie was on her way to enroll as a freshman at Hampshire College in Amherst, Massachusetts, when her mother lost control of their car and it rolled over three times. Nellie was napping in the backseat without a seatbelt.

She suffered extensive brain damage, ruptured both lungs, and her heart stopped twice on the operating table. Despite all that, Nellie not only survived, but after three years of rehabilitation, she went back to Hampshire College and graduated in four years. She then attended Yale Divinity School and eventually was ordained as a deacon. Serving God became her salvation, changed her life from one of misery to one of joy. Her accomplishments were testimony to the power of the human spirit. "I grew up with remarkable parents and a dad who taught me from childhood never to give up," she wrote.

Nellie's close friend at Chatham Hall was Charlotte Caldwell, president of the student body. They remain good friends. Nellie lives in Philadelphia; Charlotte lives in Charleston, South Carolina. Through Charlotte, Nellie has also developed close relationships with Hannah and Andy Lord of Boston and Jeffrey Schutz of Denver.

"GIVES NEW MEANING TO THE ROCKY STAIRS, DOESN'T IT GUYS?"

Each year, these friends get together with Nellie and take her annual Christmas-card photo. Nellie sends out more than 150 cards to old classmates, parishioners, and other friends she's made over the years. She has traveled all over America with Charlotte and the gang, posing for Christmas photos on a horse, a tractor, a golf cart, in front of some of America's most historic sites. This year, Nellie wanted to pose on the steps of the Philadelphia Museum of Art.

"Rocky wishes he could have had the strength, the inner strength, of Nellie Greene," said Charlotte. "She's a fan of inspiration."

"She's probably the most remarkable person I've ever met," said Andy.

They drove to the museum on a sparkling Saturday afternoon in June and parked near the top of the Rocky Steps. "Ready for your ride on the barge, Cleopatra?" asked Andy. The men carried Nellie and her wheelchair *down* two flights of steps. Nellie laughed so hard she had tears in her eyes. "Gives new meaning to the Rocky Stairs, doesn't it guys?" Charlotte asked.

Nellie posed, while her friends held up her arms in victory—Rocky-style.

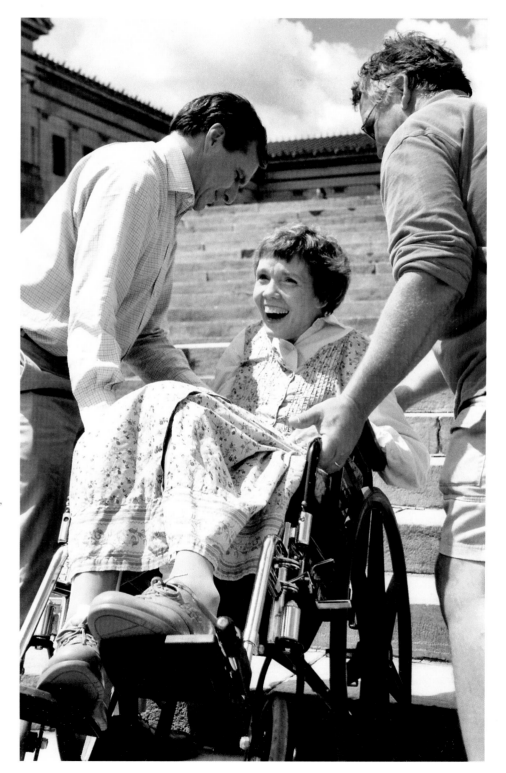

42 THE PUNK ROCK UNDERDOG

★ Josh Blackway is a sweet guy. Beneath his punk-rock exterior and tattoos, he has a heart like Rocky, a tenderness and earnestness. I expect that success in life will be by his own measure and happiness will come from following his own path.

Josh Blackway is the lead guitarist in a punk rock band called "The Huntingtons." He's twenty-four years old, and spent from 1999 to 2004 on tour. He circled Europe twice, crossed America more times than he can count.

"Rocky is a perfect metaphor for the Huntingtons," Josh said. "He's an underdog fighter. We're an underdog band."

The Huntingtons have yet to break into the big time. "Probably our greatest moment was playing two shows at CBGBs in New York City with Joey Ramone, before

he died," said Josh. "We played Ramones songs, and he sang for us. It was an unforgettable experience." In the punk music world, the Ramones are even bigger than *Rocky*.

"We were working harder than anyone," Josh said of his band, "not really trying to prove something, but more just to have fun and stay alive. Music is my life. It's my reality, as well as my escape from reality, if that makes sense."

For a punk rocker, Josh is a pretty straight guy. "We did things a little different than most

bands that were on the road all the time. We were just rock 'n' roll, minus the sex and drugs." One of Josh's favorite scenes from *Rocky* is when Sylvester Stallone tries to talk a young girl out of smoking and hanging around on the street corner with the "yo-yos." "I try to be a good example whenever I'm in front of a crowd, and off the stage," said Josh. "It's a good habit to get into. There's so many artists who fill kids' heads with junk."

Josh is from the Philadelphia area. After five years on the road—and prompted by the fact that the lead singer's wife had a baby (so

he needed a little time off)—Josh decided to go back to school at Temple University to finish his degree. He still plans to tour, just not as much.

As he roamed America with the Huntingtons, Josh made many friends, including a Californian nicknamed "Beef," who played in his own punk band, "The Carmines." Beef's real name is Ethan. In second grade, kids called him Beefan, and over time it was shortened to Beef.

Beef and his band were touring the East Coast in June when Josh brought them to the Rocky Steps,

"IT ALMOST SEEMS LIKE HE COULDN'T CONQUER THOSE STEPS."

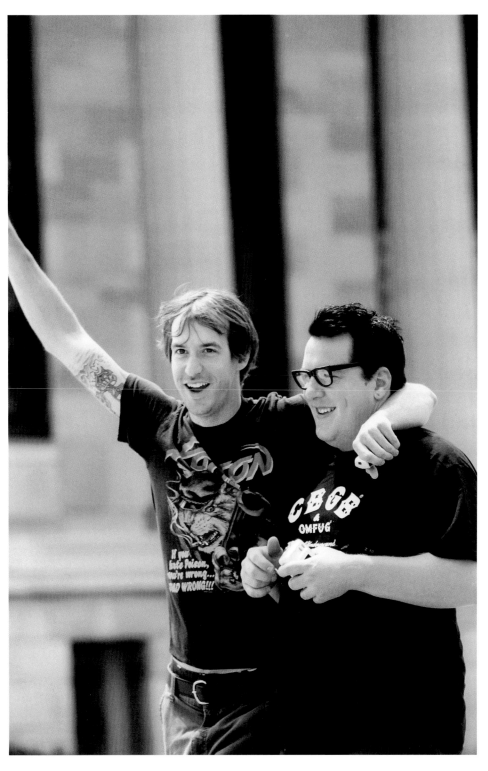

which he has run at least fifty times. The Carmines had done their homework by watching all five *Rocky* movies on DVD before heading East.

Beef, if truth be told, is rather beefy; he walked the steps. Another band member, Nate Roberts, had hurt his ankle and needed to be carried. Josh sprinted up, as usual. When he reached the top, in a moment of punk-rock euphoria, he hugged Beef.

"One thing I am always reminded of when I run up the Rocky Steps," said Josh, "is the first scene, when Rocky doesn't quite make it all the way to the top. He runs out of breath about halfway up, grabs hold of his side, and slowly turns around to walk down the steps. That scene is more memorable to me than the one where he goes all the way to the top, because it almost seems like he couldn't conquer those steps, like they were too big for him."

His youthful enthusiasm and optimism make it hard to imagine any steps being too big for Josh.

43 ROCKY IV ENDED THE COLD WAR

★ Jeff O'Leary had been through a lot. In many ways, he was lost. But here at the top of the steps, he was found. He was home. The world felt right to him, so his enthusiasm made perfect sense here—if not his revisionist history.

As Jeff O'Leary drove across the Walt Whitman Bridge into Philadelphia, "Gonna Fly Now," from the *Rocky* soundtrack, blasted from his car's sound system, and Jeff sang along as loudly as he could.

On the Benjamin Franklin Parkway, he caught his first glimpse of the Rocky Steps. "I was hyperventilating the whole way down the street," he said. His girlfriend of just three weeks, Andrea Dixon, sat beside him. "I thought we were going to get in an accident," she said, "because he was going like this"—she raised her arms in full "rocky." "And I was yelling, 'Hands on the wheel!'"

Jeff, twenty-six years old and from Stratford, Connecticut, had come to Philadelphia to attend a wedding. Those who had come with him in the car, however, knew the deeper truth. He had packed a gray sweatsuit in the trunk, and he planned to change into it before he ran the steps. He had a portable Discman and headphones, and intended to listen to the *Rocky* theme while he ran. As his car rounded Eakins Oval and the art museum steps rose before him, he couldn't help himself. He slammed the car to a stop in the No Parking zone at the bottom of the steps. "I'm sorry," he said to Andrea, and off he ran.

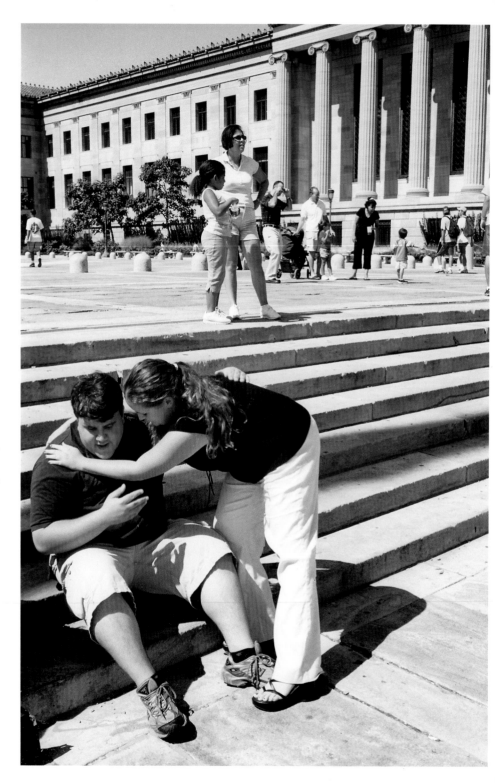

Jeff tried to take the steps three at a time, the way Rocky did, but he couldn't. "My pants were coming down," he explained. "I didn't have my belt on." He reached the top, circled, and celebrated. The late August afternoon was sunny, blue, and seventy-two degrees. "I feel so alive right now," he said, "it's ridiculous." Andrea eventually joined him at the top. "This is like the greatest moment in your life," she ventured.

"Yes, it is," Jeff answered.

She, of course, was baffled. He tried to explain: "Every guy loves the movie, so it's a frame of reference for us all. It's like none of us has read the Bible, but we've all seen *Rocky IV* like six thousand times."

"I'm learning so much," said Andrea.

Jeff attaches special significance to *Rocky IV*. In that 1985 movie, Rocky Balboa travels to Siberia to face the Russian boxing champion, a superman on steroids. Initially, Rocky is booed by an arena full of Communist Party loyalists, including members of the Politburo. He is pounded by his opponent in the early rounds, but he perseveres. By the end of the fight, Rocky triumphs, and Soviet fans chant his name and cheer for him. Rocky comes to love them, too.

"I come here tonight and I didn't know what to expect," Rocky says over the public address system at the end of the fight. "I seen a lot of people hate me, and I didn't know what to feel about that, so I guess I didn't like you much none either. During the fight, I seen a lot of changing—the way youse felt about me and the way I felt about you. In here there were two guys killing each other. But I guess that's better than twenty million. What I'm trying to say is, that if I can change, and you can change, everybody can change." Even the Politburo applauds.

Jeff quoted this passage and then added, "What happened the next year? The Berlin Wall came down. *Rocky IV* ended the Cold War."

Andrea just laughed.

"It did," he insisted. "I'm convinced of that."

The Berlin Wall actually fell four years later. But that is a minor detail in Jeff O'Leary's story. Jeff is confident that history will reflect the truth, and the impact of his favorite movie will be recognized.

Jeff would have lingered all afternoon at the top of the Rocky Steps, but a police cruiser was pulling up next to his car. He had to go.

"IT'S A FRAME OF REFERENCE FOR US ALL."

THE MUSIC THAT MADE ROCKY FLY

Virtually everyone who runs the Rocky Steps these days hears the *Rocky* anthem playing in his head. Bill Conti was a recent graduate of the Juilliard School in New York when he was hired to compose the score for the movie. Director John G. Avildsen sat down with Conti one day, offered him a glass of red wine, and showed him a few of the rough cuts of Rocky boxing Apollo Creed. Avildsen played a recording of Beethoven's *Pastoral Symphony* as they watched. His marching orders to Conti, he recalled, were simple: "That's the kind of sound I want, rather than a rock and roll. This music makes boxing more important, almost more ethereal.

"It's a fairy tale," the director added.

"I think I got it," Conti replied, and headed off to his piano.

Conti composed the entire score in just three weeks. The first pieces that he wrote—in fact, most of what he wrote for the movie—consisted of sad music. After all, Rocky Balboa was a loser, down and out. But for what he referred to as the "montage sequence," when Rocky runs through the city and finishes triumphantly at the top of the museum steps, Conti sought an inspiring sound. Now he needed music "to make the people believe the hope, that Rocky might be able to pull this off."

Conti had read the script, but he had not seen any cuts of Stallone running the steps, and he had never been to Philadelphia. His inspiration needed to come from within. He thought to himself, he recalled in an interview, "Let the hopes of this loser soar." He tried to imagine how he would feel in his own heart, if he were Rocky—and to write music

that would convey that feeling. He had faith that moviegoers would respond. "I hope in our humanity," he recalled, "the other guy gets it."

He wrote that memorable music for the scene at the steps in a single day. This is the music that runners hear in their heads. In the film, it is played by a thirty-two-piece orchestra. For some runners though, hearing it in the mind's ear isn't enough. They bring portable disc players, MP3 players, boom boxes, and even laptops—as Miffany Henley did the week before Christmas. In the can-do spirit of America, one runner had his cell phone ringing as he ran. His ring tone? The theme from *Rocky*, of course.

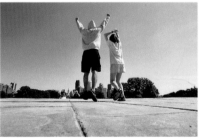

The famous anthem begins with the same fanfare that opens the movie—a blast of trumpets. Conti called for six trumpets because

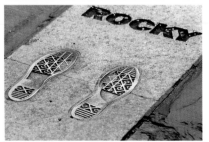

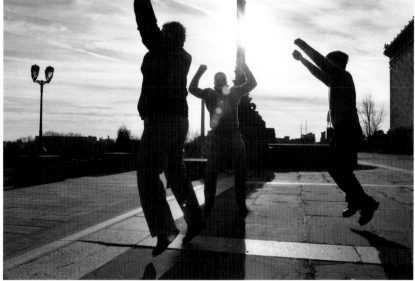

can't recall them, it has lyrics, too. The women who sang these lyrics worked in an office with Bill Conti's wife. They weren't professionals. They set down the tracks during lunch breaks.

"When it's magic, it's magic," said Conti. "It's not *sort of* magic. Magic has its own category."

Just as it did for writer-star Sylvester Stallone, director John Avildsen, and Steadicam inventor Garrett Brown, the movie completely changed Bill Conti's life. He was nominated for an Academy Award for best original song for "Gonna Fly Now," (though he didn't win an Oscar until 1983, for his music for *The Right Stuff*). He later won three Emmy awards and was nominated for ten others, writing theme songs for some of America's most popular television newscasts and sitcoms.

"It changed my life dramatically," Conti said. "It gave me cachet…Without *Rocky*, there's no career."

Conti also said he was humbled to learn that people continue to run the steps. "The message was so meaningful that it doesn't have to go away," he said. "It's so nice to know that people are moved enough to do that. It's such an incredible thing to have moved somebody with music. It's an honor and a blessing, and you thank God you could do that." ★

just one or three or even five wasn't enough. "That brassy sound is what the Greeks and the Romans want you to hear going into battle," Conti said. "That is the part that makes guys want to die. Harps when they want to have sex. Trumpets when you go into battle."

The anthem has a name, "Gonna Fly Now," and though many people

FALL

44 A LEAGUE OF HER OWN

★ Marika was quite the sight, lugging her bags and camera up the steps. But she knew what she wanted, went after it, and savored every moment of her adventure. She struck me as someone whose life was not particularly easy, but she was a "glass-half-full" woman. And like so many of the runners I met, she invited me to visit her home—in Australia.

Marika Forras was a single mother, raising a young son in the suburbs of Melbourne, Australia. She volunteered in her spare time working with underprivileged children, and she took a group to see a game in the Australian Baseball League.

She met a man there (now a scout for the Atlanta Braves). He told her to get her son started playing baseball, a great sport. She began taking him to tee-ball at eight o'clock on Sunday mornings. Her son really liked baseball; *she* fell in love with it.

An advertisement for a new women's baseball league prompted Marika to sign up. Her Austrian mother had been an Olympic skier, her father a member of the Hungarian Olympic team. She'd never swung a bat or thrown a pitch, but at age thirty-three, she became a first baseman for the Port Melbourne Mariners. About that time, she also started a new

job, working the night shift as a reservations operator with Quantas, the Australian airline.

As the years went by and her love of baseball grew, she made a promise to herself: If she worked for ten years with Quantas and received her three-month paid leave, and if she were still playing baseball then, "I'm going to fulfill my dream of seeing a baseball game in every major league park in America."

She had to begin planning years ahead. She teamed up with an American friend and baseball player, Debbie Pierson of Oregon. Deb feared that Marika, accustomed to driving on the left side of the road in Australia, would never make it on American roads, so she offered to do the driving. The two women eventually traveled more than twelve thousand miles in Deb's fifteen-year-old Honda Civic—with no air conditioning.

Although it had taken Marika years to save the money and make

her plans, the minute she walked into Dodger Stadium in Los Angeles, she knew she had made the right choice. "This was a dream come true," she said.

Not only did Marika take in all the ballparks, she also met players, coaches, and fans. She toured museums, parks, historic sites. "The people have been fantastic. They take me into their hearts," she said. "I'm the envy of most Americans because it's their pastime and their game, and I'm an Aussie and I'm doing it."

Near the end of her trip, her twenty-seventh of thirty games, Marika arrived in Philadelphia. She had long been a *Rocky* fan, and knew the one thing she just had to do in this city. "Running the Rocky Steps means you have accomplished

"RUNNING THE ROCKY STEPS MEANS YOU HAVE ACCOMPLISHED SOMETHING."

something," she said. "This tour of mine has been a mammoth adventure. Running the steps was a chance to revel in the fact that I could overcome anything that was put in front of me."

Marika ran slowly. She was weighed down with shopping bags and carried a video camera to record herself as she ran. She sang the *Rocky* theme song as she ascended, and she talked to herself, reminding herself to take it slow, that she could do it. She "rockied" at the top.

"As I ran the steps, I was thinking that life could not get any better, and I could not believe that I was actually doing this. When I reached the top, I was exhilarated and wished that my son and close friends were with me to enjoy the moment. I had conquered my mountain, and turning around to see the beautiful city of Philadelphia, I thought to myself how lucky I had been in life to experience moments such as this."

45 WOMEN WEAKEN LEGS

★ I've always loved writing about people who have a passion about what they do. It is perhaps the best thing about being a journalist and feature writer. Dave had waited years to come to the Rocky Steps. His passion that day was in full bloom.

Dave Bauer has instructed his wife, Jean—and she's told everybody in their extended families (in case she dies first)—that he wants the song "Going the Distance" from the *Rocky* soundtrack played at his funeral.

"He wants to enter heaven listening to *Rocky*," Jean said.

Specifically, Dave wants the song played just as his casket is being carried from the church. He believes the *Rocky* story is one that emphasizes good values—honesty, dedication, faith—just as he has tried to do. "I hope that I have passed on good values so we can all go the distance together," he said.

Dave, forty-two years old, went to a small Catholic grade school and high school. He didn't have many friends as a boy. "I guess I always just felt like an underdog," he said. "And by looking at *Rocky*,

I got hope. Every underdog can identify with Rocky." Dave's fascination started when the movie first came out, just as he was entering his teenage years. "I used to be able to do one-armed pushups," he boasted. No longer.

He has a wonderful wife and two daughters, and a good but grueling job as a structural engineer. Each time he begins a new project, he feels like Rocky Balboa entering the ring. He knows he's going to get beat up by clients, by contractors, and by deadline and financial pressures. But he stays in there; he has to. Because of this, as he's grown older, the *Rocky* story has resonated with him even more. "*Rocky* represented the common man

"ROCKY GIVES HOPE TO ME WHEN I'M KNOCKED DOWN."

being knocked down day after day, but he refused to stay down," said

Dave. "*Rocky* gives hope to me when I'm knocked down."

His daughters and their friends are far more interested in Smack-Downs than knockdowns. Dave and Jean had driven all the way to Philadelphia from their home in Rome, New York, with daughters Mary, twelve years old, and Sara, thirteen, and their three girlfriends, to see a professional wrestling event, a SmackDown, at the Wachovia Center arena in South Philadelphia the previous night.

Dave now had only one item on his agenda—to run the Rocky Steps. And he kept giving the kids instructions.

"Everybody's got to jump!" Dave commanded. "Ready, Mary?"

"You and your *Rocky*," groaned his daughter.

Dave wanted to be sure his wife got photos and video from every angle. He had waited years to

come here. Who knew when he'd be back? He made them all run the steps three times. When one of the girls tried to pass him on the third trip, he shouted what all of them should have known: "Nobody's allowed to pass Rocky!"

Dave's favorite line from *Rocky* is "Women weaken legs!" barked by Burgess Meredith as Rocky's manager, Mickey, when he cautions the fighter against getting too affectionate with Adrian.

"That's what I tell her when I'm not in the mood," Dave said, nodding toward his wife. Jean just laughed; she's used to him.

Dave was finally satisfied with the video and photographs. Back to the car they trooped. They had watched *Rocky* on DVD in the minivan on the drive down. "We'll watch *Rocky II* on the way home," Dave said. The girls groaned. For them it would be a long trip. Not for Dave.

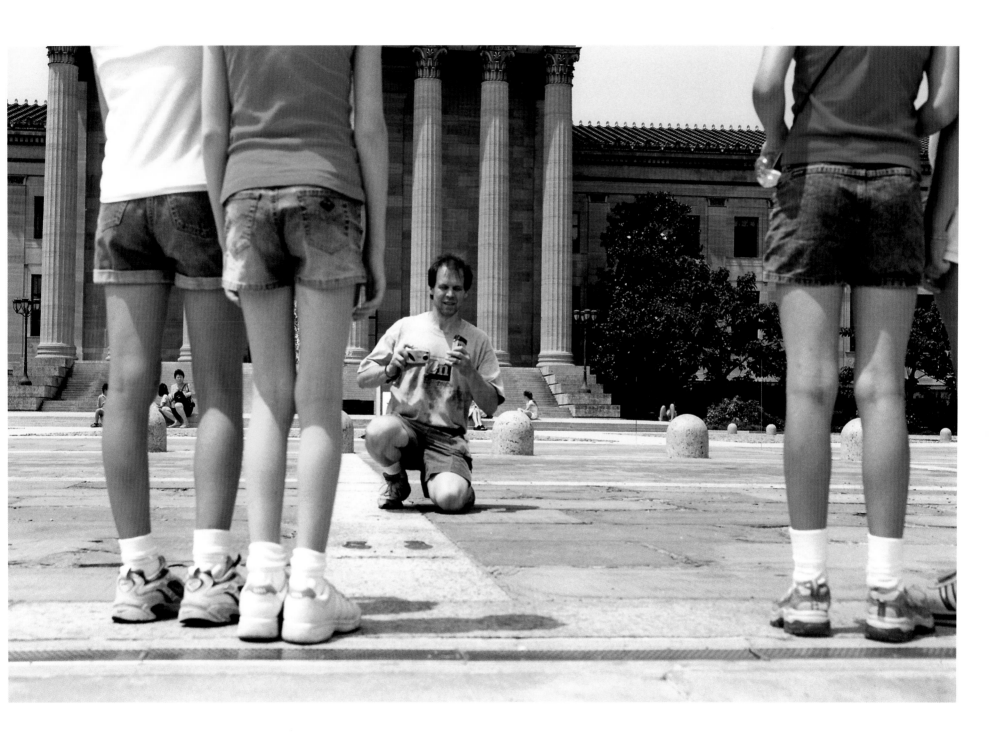

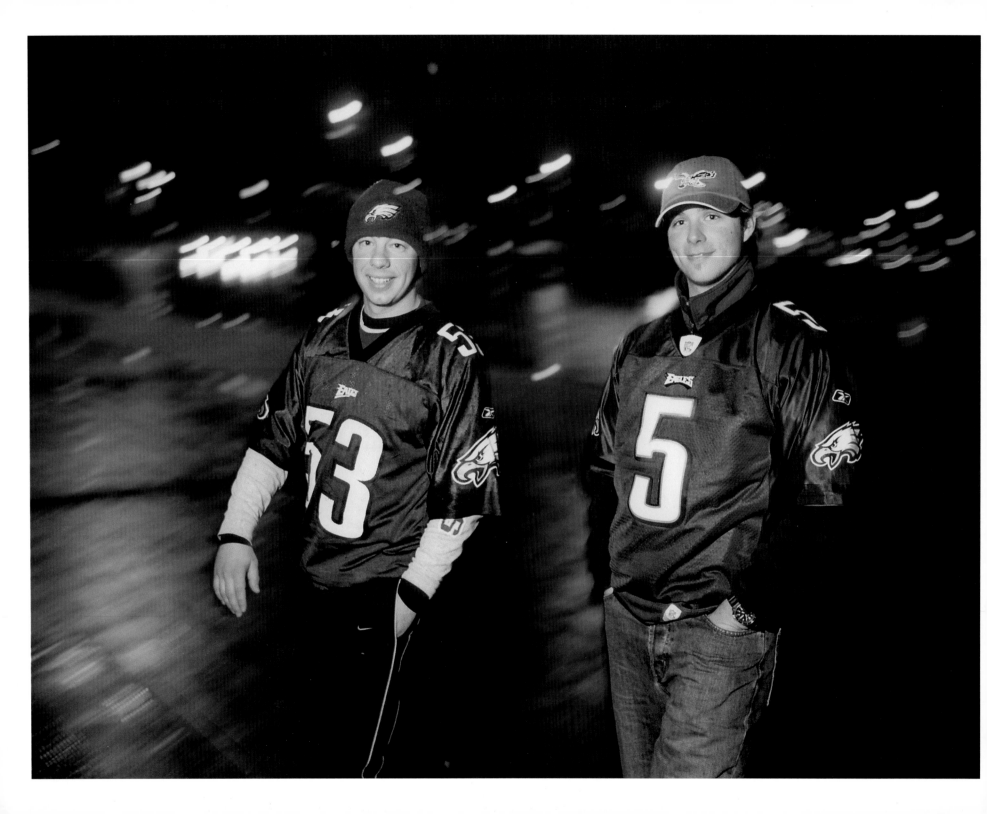

46 E·A·G·L·E·S

★ On Halloween night, I hung around to see if anyone would run in costume, but nobody did—it was cold and raw. I forgot the weather altogether, though, when I saw two men bolt from an SUV and one of them shoot to the top of the steps wearing a Philadelphia Eagles jersey. Every day at the steps, another surprise.

Kevin Quinn and Rob Del Monte have been best friends their whole lives. Rob's earliest memories are of playing football with Kevin, at age four, both in their Philadelphia Eagles jerseys. They went to school together from first grade through twelfth and were co-captains of their high-school soccer team at Wildwood Catholic, in Wildwood, at the New Jersey shore. On fall weekends, when they weren't watching Eagles football games, they would often watch *Rocky* movies.

"When you watch the movies, it gives you that feeling that anything is possible if you want it enough," said Kevin. "Ever since I was little, I have understood that meaning."

Neither of these guys came from money. Rob's dad bought a small motel in Wildwood and raised his family there, working a second job at night parking cars. Kevin's parents divorced when he was small. "It wasn't a terrible situation," Kevin remembered, "because they remained friends, but it wasn't a strong nuclear family. I just felt that I had to fight a little harder to be a success."

They went to different colleges, but both of them returned to Wildwood after graduation and picked up where they had left off as best friends. Rob went to work for the family business, now expanded to three motels. Kevin taught geometry at their old high school. He took a year off, but missed it terribly, which confirmed for him that it was the career he wanted and Wildwood Catholic was the place he ought to be.

For the past several years, Kevin and Rob have purchased season tickets to their beloved Philadelphia Eagles. One of

"IT GIVES YOU THAT FEELING THAT ANYTHING IS POSSIBLE."

their pre-game rituals has been to listen to the soundtrack of music from *Rocky* to pump themselves up as they make the ninety-minute drive from Wildwood to Philadelphia on game days. Sometimes, before they set out, Rob will dial other friends on the phone, blare the *Rocky* music into the mouthpiece, and hang up without even speaking. The friends all know who called.

This year, the Eagles had gotten off to their best season ever. The team won its first seven games. After the seventh victory, a home game against the Baltimore Ravens, Kevin was just too excited to contain himself. He and Rob decided to detour to the Rocky Steps on their way home from the stadium. Rob, whose father is originally from Philly, had run the steps many times, but Kevin never had. Now, the spirit moved him.

On that cold, raw evening, Kevin surged from the passenger side of their SUV and bulled up the steps in his green, No. 5 Eagles jersey, the one worn by quarterback Donovan McNabb.

"Running the stairs felt awesome," Kevin said. "That building is so big and seems so distant from the bottom of the steps. I guess that at the finish you get the feeling that you accomplished something."

Kevin, at twenty-eight years old, feels he has accomplished his own version of the American Dream. He is back in his hometown, doing work he loves, hanging out with his best friend—and he's engaged to be married. "Waking up, being alive, enjoying what you do for a living, finding spare time to do the things that make you feel happy and alive, that is success. It's all about balance in life. The mere fact that we have the freedom to make choices is enough for me."

47 ARMY-NAVY

★ Nearly every story in this book was a random discovery at the museum steps. This one was an exception. We learned in advance about the Rocky Relay. Rather than focus on one of the cadets or midshipmen, however, I was drawn to Sergeant Jones. He appeared to relish the steps and the event more than anyone else.

The day before the annual Army-Navy football game in Philadelphia, cadets and midshipmen face off in another, less well-known but no less epic, competition, the Rocky Relay. Five of the finest from each academy—in classic *Rocky* fashion—must each do five one-armed pushups, jump rope twenty-five times, and then sprint up the Rocky Steps, celebrating at the top. As soon as one team member reaches the top, the next one begins the sequence of push-ups and jump rope at the bottom.

The year before, Navy had rocked Army in the relay. This year, Army came back prepared.

First, Army held tryouts. Cadets throughout West Point were summoned, tested, timed, and trained. Ultimately, their number was winnowed down to five, with two alternates. "The whole process was kind of like *Survivor*," said Jessie Baker, one of the Army alternates.

Army also had Richard Jones, master sergeant. At thirty-six years old, he was the spiritual leader, the drill sergeant, if you will, of the Army team. "I wanted to motivate cadets to do their best, and I thought that I was the best man for the job," he said. Sergeant Jones grew up in Detroit, with little education and less money. The United States Army showed him the world and, more importantly, showed him that he could accomplish anything he set his heart on. After all, as a training officer assigned to West Point, he is preparing the leaders of tomorrow. That shows what the Army thinks of Richard Jones.

Persevering in the Army, much less succeeding, was often difficult over the years—so difficult that many times Master Sergeant Jones wanted to quit. He frequently turned for inspiration

"HE'D ROOT FOR ARMY." "HE'D BE A MARINE."

to *Rocky*, a movie he had watched repeatedly with his brothers while growing up. "Just because of watching the movie," he said, "I kept going and never attempted to quit what I was trying to accomplish. If this movie was not based on a true story, the story was true to me."

Sergeant Jones had never before seen the Rocky Steps. His cadets were to begin racing at 8:30, but he arrived at 7:30 on that sunny, cold December day to run the steps himself. He celebrated at the top, shadowboxing in the morning air. "Running up those stairs for the first time made me feel like a kid again watching *Rocky*."

As the two teams warmed up, I asked members of each squad whether Rocky would favor Army or Navy.

"He's never even been in a boat, I'm sure," said Army cadet Baker. "He'd root for Army."

"He'd be a Marine," said Mike

Maher, a midshipman. "He's the best."

Before the Rocky Relay began, referees met with both teams to make sure each side understood exactly what constituted a one-armed pushup. Master Sergeant Jones volunteered to demonstrate and hit the pavement, pumping out five as if he were, well, Rocky Balboa.

Just before the start, Sergeant Jones drew the cadets close. "One team. One fight," he told them. "Beat Navy."

As the relay was underway, Sergeant Jones ran up the steps alongside each cadet, cheering him as he ran. They didn't need his cheering, because they'd already had his preparation. Navy didn't stand a chance.

After their victory, the Army team rode back to their hotel in a van. Navy walked.

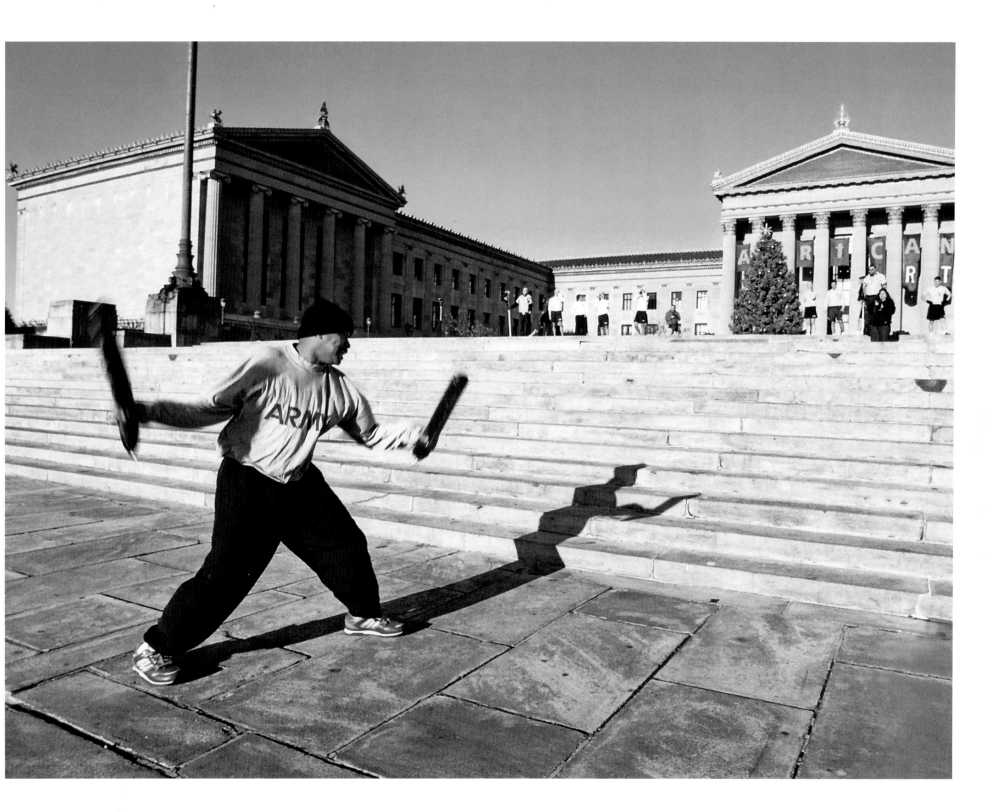

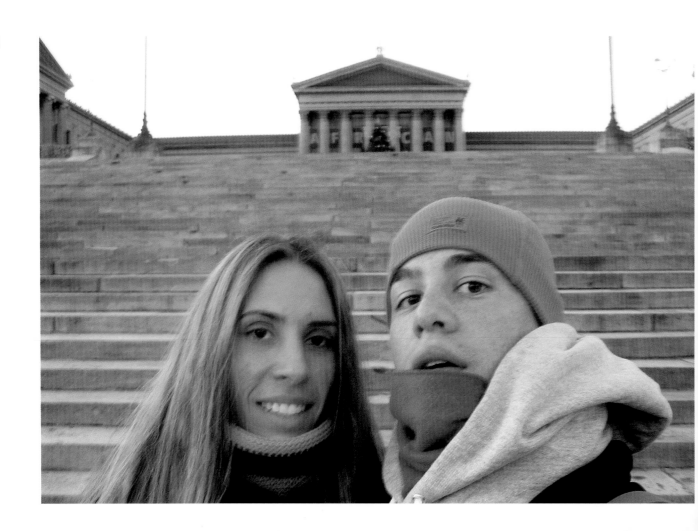

"ROCKY'S PART
OF AMERICA,
PART OF OUR
HISTORY."

48 CHRISTMAS PRESENT

★ I rode my bike over to the museum on a gray December afternoon. As I arrived, I saw a young woman sitting on the ground, bundled up like an Eskimo. She had a laptop computer and a video camera at her side. Soon, the *Rocky* theme was playing loudly and her boyfriend was bounding up the steps. This was too good to be true. But Tom wasn't with me, and I didn't have a camera. Luckily, Miffany did, and the couple took a self-portrait.

Richard Brock was growing up among the middle-class in Alberta, Canada, when his parents lost their jobs and relocated to Florida, where they found minimum-wage work, and started over. "I learned life does not owe you anything," Richard said. "Life is a fight. I believe you have to fight for the life you want and all in it."

Richard also grew up watching *Rocky* and the sequels. "I have always felt a connection to Rocky," he said. "He had hard breaks through life and never complained. He had morals and values and stood by them. He changed his destiny."

While standing in line to register at the Florida Hospital College of Health Sciences in 1998, Richard met Miffany Henley. He was there to get a nursing degree. She enrolled to become an X-ray technician. They have been a couple since that day. Early on, Miffany learned about Richard's affection for, and identification with, Rocky. Just as Adrian does in the movie, Miffany gave Richard a dog; and just as Rocky does in the movie, Richard named the dog Butkus.

Now twenty-five years old and a nurse, Richard works the overnight shift on the critical care unit of an Orlando hospital. When patients are struggling for their lives, even when a Code Blue has been called, he encourages them to cling to life in the best way he knows how—with a mantra from *Rocky III*.

"I'll say 'Eye of the Tiger, man! Look at me.' And they're there. They just come back. They'll pull through it," he says. Not every time, but sometimes. He believes that deep down, as they battle for life, they understand what he's saying. "*Rocky*'s not short-term memory, man," Richard explained. "*Rocky*'s part of America, part of our history."

For Christmas, Miffany bought two plane tickets to Philadelphia, so Richard could run the Rocky Steps. In order to make the trip a surprise, she put a picture of the museum steps into a green envelope along with the printout of an electronic plane ticket and hotel reservation, and tucked them inside Richard's lunch bag. When he opened his lunch at three o'clock in the morning, Richard let out a whoop that woke up half his patients.

In December, Richard and Miffany spent three days in Philadelphia. They went to Independence Hall. They visited South Street, the Bourse, the Liberty Bell. But the finale, the last thing before heading to the airport to catch a plane home, was their visit to the Rocky Steps. It was a cold afternoon and they had the museum steps to themselves. Miffany is a Conch, a native of Key West, Florida, and the windy, thirty-five-degree weather felt arctic to her, despite a down coat, mittens, hat, and scarf. Richard wore the sweatshirt he had just bought for this occasion—with a gray hood and a silhouette of Rocky, in full celebration, on the front. He stood at the bottom, staring up the steps in awe.

For a second time, Miffany surprised him. She pulled a laptop computer out of her backpack. She hit the play button, and music from *Rocky* began blaring from the tiny speakers. Richard took off running, two, three steps at a time, as Miffany videotaped his ascent with the *Rocky* theme playing in the background. Richard soared to the top. He has climbed Mount Yamnuska in the Canadian Rockies, but this was "more amazing." He felt more alive, more in love, more appreciative of what he had accomplished.

He descended slowly. When he reached Miffany, they kissed. "That was the best Christmas present ever," he said. "I felt like Rocky, on top of the world."

49 CHEVALIER'S TEAM

★ These California high-school girls were living a *Rocky*-like story of their own. Each of them faced adversity. Basketball was their goal, maybe their ticket to a better life. Michele Chevalier knew they needed a pick-me-up after a disappointing tournament, and a visit to the Rocky Steps proved to be just the tonic.

Great things are expected of the girls' basketball team from Sylmar High School, north of Los Angeles. Three years ago, they lost the Los Angeles city championship by one point. This season, they were expected to return to the championship game. The pressure on these girls is immense.

Sylmar is a struggling community, where 90 percent of high-school students are eligible for free lunches. LaShay Fears, the senior point guard, is one of eleven children. In December, she signed a letter of intent to attend the University of California, Santa Barbara on a full scholarship. She will be the first one in her family ever to go to college.

"It's been such a struggle for her, financially, you know with eleven kids," said her coach, Michele Chevalier. "She's moved at least ten to twelve times, literally, since her freshman year. She now lives an hour away from school and gets up by 4:30 A.M., and gets dropped off at a teammate's house by 5:00, just so she can get to school.

"I've taken her under my wing," Chevalier continued. "At one point she was living with me this past summer."

This coach, just thirty years old, knows something about desire, dedication—and mothering. When she was a junior at Long Beach State University, she got pregnant and took a year off from basketball. But she came back the next year, mothering her son and her teammates. Now, in only her fifth year of coaching, Chevalier has already been recognized for her skills by being named an assistant coach for the McDonald's All American High School Girls Basketball Team.

Chevalier instructs the Sylmar players in her own "ABCs: Academics, Basketball and Character." She explained: "First and foremost are academics. These girls are students. I encourage them to take the

"MAYBE YOU'LL FEEL LIKE A CHAMPION FOR A MOMENT."

classes they need to be successful, to learn how to be a student first." That aspect of her philosophy is obviously working; the team maintains a 3.3 grade point average overall.

"With the basketball, there's only one way to play for me, and that's hard," she added. "I can live with mistakes as long as you're working hard. I will take a kid that is less skilled, but if they work their butt off for me, they have a spot on my team. The C at the end is 'character.' I stress that when they play for me they're representing their school, their family, their program."

In December, Chevalier took her team to the Diamond

Classic tournament in Wilmington, Delaware. They didn't play very well, winning only one game. Before flying home, they had some free time, so Chevalier drove the team to Philadelphia to eat cheesesteaks—and to run the Rocky Steps.

"We're struggling a little bit," the coach said. "We need to find ourselves. We need to learn how to be champions, to learn how to win." She thought running the steps might create that frame of mind. "Maybe you'll get the idea," she encouraged her players. "Maybe you'll feel like a champion for a moment."

No one hit the steps harder than senior guard Train Thompson.

"Train's had that nickname since sixth grade," said her coach. "The first day she practiced, I knew why they called her that. She was clearing the lane, and people moved out of her way. There was no stopping her."

There was no stopping Train on the Rocky Steps, either. She flew to the top, and then she celebrated, big-time. So did many of the other girls. Coach Chevalier said she knows what she's going to do the night before the city playoffs begin. She's going to have everybody over to her house, and they're all going to watch *Rocky*.

5 0 THE SOUTH AFRICAN

★ Once I had started to speak with Elsie Oosthuizen, her glow, her sense of happiness, just washed over me. She seemed to make so much sense, to appreciate the moment—being with her children, together, for the first time in years. Do people gain clarity because they are at the steps? Or did they put their lives in perspective for me because I asked them to reflect and share?

Elsie S. Oosthuizen of Johannesburg, South Africa, lagged behind her daughter and son-in-law as they ran the museum steps, but she compensated for her lack of speed with an abundance of zeal. At sixty-one years old, Elsie's hair is still thick and full; tied in a bun behind her head, it bounced up and down as she ran.

Her children waited for her at the top. "Yes! Yes! Yes! We did it!" she exclaimed, high-fiving her daughter, Deirdré, and son-in-law, Jacques, and then "rockying" at full throttle. "We wanted to do it," she said. "We had to do it."

This was the last day of the year, and Elsie couldn't remember ever being happier. She was on vacation with her husband, Willie, and their two children and their spouses. Her son, Morné, and his wife, Maurine, live in America, and this was the first time in six years that all six of them had been together for Christmas and New Year's. "The world in miles disappears when we see each other," said Elsie.

Morné and Maurine had lived in Philadelphia when they first moved to America, and he wanted the others to see the city. His mother insisted they run the Rocky Steps. "I simply just had to run them," Elsie said.

"I was feeling great, and I experienced an excitement I could not explain," she said afterward. "It felt as though I was liberated from all the cares of the world. What a wonderful way to end our visit to the Land of the Free!"

Elsie works as a receptionist at a clinic for employees of Anglo American, South Africa's biggest mining company. She loves people and believes she can make a difference in her coworkers' lives just by listening when they are sick or feeling down.

"A great part of their problem usually lies in stress caused by personal or employment problems," she said. "By simply just listening to them, it relieves most of the tension and they feel better already before being attended to by the medical staff. My motto here is, if I can help somebody along my way, then my living has not been in vain."

Willie, Elsie's high-school sweetheart and husband of thirty-seven years, was the one who turned her on to *Rocky*. He boxed when he was young, and won his first six fights convincingly, but his strict father insisted he stay home every night of the week, to make sure he didn't fall behind in his schoolwork. With that, Willie's boxing career ended in his early teens. "I think this explains the interest Willie had in the *Rocky* films," said Elsie. "Perhaps dreams that never came true?"

Willie was the twelfth of fourteen children in a poor family, and even though his marks in school were good, there was no money available for his education. "It meant that he could not attend university and had to see other employees, less skilled, experienced, and dedicated, being promoted mainly because of their qualifications," said Elsie. "That was when he decided that his children would get every opportunity to get further education, no matter what! Willie's ambition was fulfilled, because today Morné is a chemical engineer, living and working in the USA, and Deirdré is a qualified physical therapist hoping to start her own private practice this year in KwaZulu-Natal, South Africa."

Willie didn't run the steps. He was content to film his family running, to smile broadly, and to say to himself, "What a wonderful world."

"I SIMPLY JUST HAD TO RUN THEM."

51 THE PROPOSAL

★ I never knew what would happen at the steps, or when. I think I was just as surprised as the bride-to-be, when the proposal came. "Oh my God," I thought. "He's on one knee!" I watched quietly, along with all the tourists who had figured out what was going on, before I approached the newly engaged couple.

Eric Williams fell in love with Julie Reeb in the summer of 2002 when she joined him working behind the bar at the Lyon Oaks Golf Club in suburban Detroit. It took Eric nearly a year to gather the nerve to ask Julie out, but after just one date, they became inseparable.

Eric, an elementary school teacher, has had a best friend since kindergarten, Alex Baker, who lived with his wife, Kristin, in Philadelphia. When Eric and Julie decided to visit Alex and Kristin there for New Year's, Eric had an ulterior motive: six months before, he had decided he would propose marriage to Julie at the top of the Rocky Steps.

"We both love the *Rocky* movies," he said, "and I knew the scenery would be a great backdrop to a perfect moment." He also knew "she would never think that I would do it there." To make certain that Julie wouldn't see a proposal coming, Eric told her three weeks before Christmas not to expect a ring. He just didn't have the money.

On the last afternoon of the year, they "just happened" to be driving past the Philadelphia Museum of Art. The six in the car—Eric and Julie, Alex and Kristin, and Alex's brother and sister-in-law, Max and Tammy—were all in on the plan, except for Julie, of course.

"Let's run the steps!" suggested Eric.

Julie responded honestly: "Oh, we're not going to run, are we?" She had watched the *Rocky* movies countless times with Eric, but it was nearly two o'clock and they hadn't eaten all day. She was hungry.

They parked the car, and as everyone walked toward the steps, Eric began singing "Eye of the Tiger," the anthem from *Rocky III*. "We were singing to pump us up to run the steps, just like Rocky used the song to pump himself up for the fight against Clubber Lang," Eric recounted.

"WE'RE NOT GOING TO RUN, ARE WE?"

As he ran the steps, Eric had a lot on his mind. He was hoping he wouldn't fall or run out of breath. (Alex had even joked that he should bend down and act like he was short of breath after the run, to throw off any suspicions, but Eric rejected that idea.) He was also hoping with all his might for one more thing: that Julie would say "Yes."

The six of them ran up the steps in the brilliant sunshine. They looked like so many others, just having fun, enjoying the moment. Then Eric dropped to his knee, right near the Rocky footprints. He opened a small jewelry box to reveal a diamond ring glinting in the sun.

"Oh, my God!" was Julie's reaction. She was clutching her small pink purse.

"Will you marry me?" Eric asked.

Their friends were all pointing cameras, snapping away. Julie was confused, almost stunned. Eric slipped the ring on her finger, then tears rolled down her cheeks.

"I'm like so shocked right now," was all she could think to say.

Finally, Alex had to know: "So what is your answer?" he called out.

Julie, as you might expect, had been so blown away that she couldn't respond, but she regained her wits and let out an emphatic "Yes!"

Eric stood up and kissed his new fiancée. Everything had worked out perfectly—the setting, the surprise, the answer. "I think Julie really brings out this compassion in him," Alex said later. "She hasn't changed him, but only brought out the best in him. You could say that Adrian brought out the best of Rocky."

You could say the Rocky Steps bring out the best in people. Let's hope they always will.

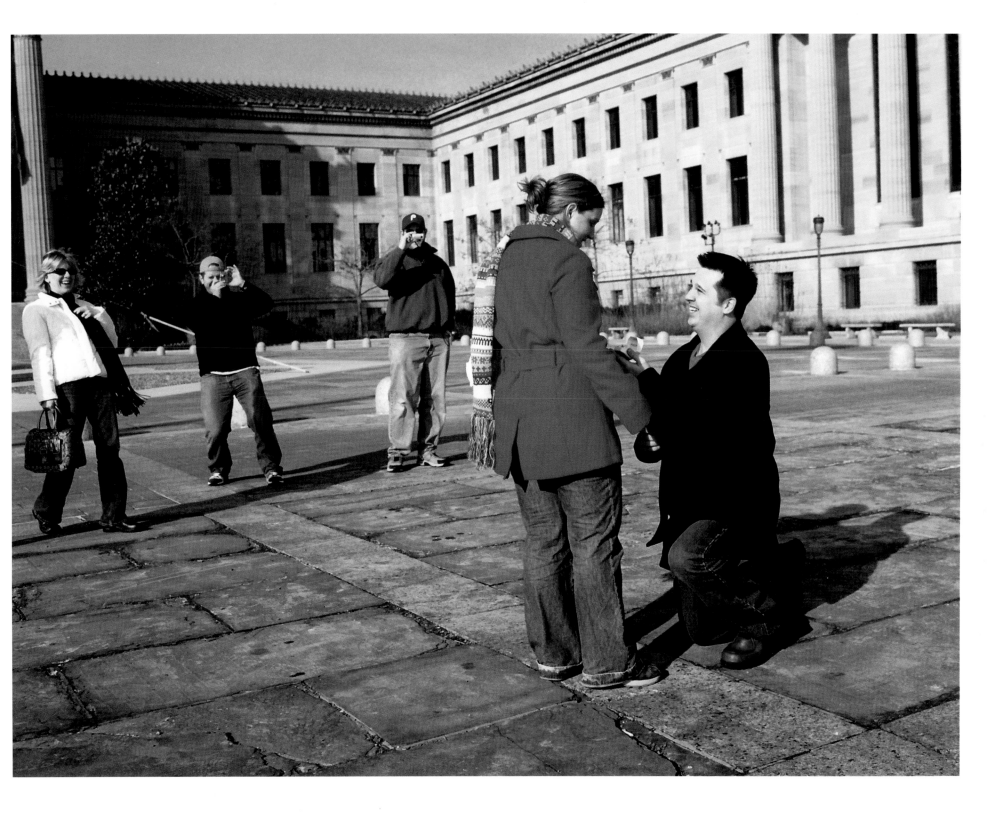

52 POSTSCRIPT: FOREVER ROCKY

★ I had met John on a story for the newspaper a few years before I decided to do this book. I remember one time I watched him becoming Rocky in a men's room, blackening his eye, applying the blush. People stared. But I also saw the faces of people when they met John in character; serious expressions melted into smiles. Once, I overheard him call home on his cell phone: "Yo, Adrian," he said. "It's me, Rocky." This is a man who loves what he does.

John Monforto of Woodstown, New Jersey, begins his transformation by donning an old gray sweatsuit, the fifth one he's owned in ten years of impersonating Rocky Balboa. He wraps a white towel around his neck, pulls a navy watch cap on his head, and laces up his black Converse hightops. Then comes the makeup. He applies Midnight Jazz blush to make his eye look black and swollen. He uses black eyebrow pencil and red lip liner to give the appearance of cuts. His final touch is two Band-Aids, one across the bridge of his nose, another over his left eye.

Then he reports for duty, often at the steps of the Philadelphia Museum of Art.

For a decade, Monforto, a writer and entertainer, has played the role of Rocky for conventions, charity events, parties, and a variety of city functions. He specializes in "ambient" entertainment. He mingles with people, in character, showing them a good time. He has

perfected the swagger, the bounce, and the voice of Sylvester Stallone. "The voice came to me natural," he says. "First time I tried it, it was there."

John was at the Rocky Steps at 6:30 A.M. one day to greet two busloads of periodontists who were in Philadelphia for a convention. He would start them on a five kilometer fun-run that morning. As they filed off the buses, the periodontists grinned broadly at the sight of Rocky. "Yo, how youse doin'?" he said in a beautiful, lowbrow tone. He even shut his blackened eye when he spoke to amplify the effect.

He noted the dawn skyline: "Isn't that bee-yoo-tee-ful?" He pointed down the Benjamin Franklin Parkway to a building, America's first modern skyscraper, built by the Pennsylvania Society for Savings in 1922, which still features the PSFS letters at the top. "That stands for 'Periodontists Stretch for Safety,'" he blurted in Rocky-speak. He identified City

Hall. "We're going to get that statue of William Penn taken down . . . and put my statue up there."

"Where is your statue, Rocky?" a periodontist asked. Periodontists know how to inflict pain.

"Ohhhhh," John thundered, "that's a sore spot. They moved it to South Philly." He gave them a look of complete bewilderment. "What? You think people come here to see art?"

John took a hit in his impersonation business after 9/11, when the mood of the country changed. Earlier, he had seen a drop in business when Ed Rendell left office as mayor of Philadelphia in 2000. Rendell loved him and hired him often. But John doesn't do only Rocky Balboa. When he's not Rocky, he's Elvis. When he's not Elvis, he's one of the Blues Brothers (his dentist plays the other). And when he's none of the

"WHAT? YOU THINK PEOPLE COME HERE TO SEE ART?"

above, he does a Sinatra review or a *Sopranos* take-off.

John auditioned to be Sylvester Stallone's stand-in for the filming of *Rocky* in 1976. The casting director, he says, told him he was perfect, but he didn't get the job. John believes Stallone, himself, made the decision not to use him: "He doesn't like people who look like him," John said. (I didn't ask how he knew this.) "And I was too tall." The Rocky impersonator is six-foot-one. The movie star is five-ten.

John has two daughters in college now. He and his wife recently sold their house, ready to downsize into a smaller one. But he's got to keep working—tuition bills to pay.

"Rocky is still a huge part of my bag of tricks," he says. "Rocky always knocks them dead. He will stay with me as long as I'm able to do what I do. I'm so grateful to Stallone that he created this character."

ACKNOWLEDGMENTS

First, I want to thank all the people at the steps who trusted me and opened up their lives to me. Thanks to Murray Dubin for suggesting a tape recorder; to Christy Fletcher for her early support and efforts; and to Carrie Rickey for all her help. Thanks to Paul, John, and Will at Paul Dry Books for believing in this project; to Kevin King for never giving up on me; and to a host of people who work for the Philadelphia Museum of Art, the Fairmount Park Commission, the Philadelphia Convention & Visitors Bureau, and the Greater Philadelphia Tourism Marketing Corporation. I also want to thank my *Inquirer* colleagues for their encouragement and advice, and Tom Gralish for being a great partner. Most of all, I thank my wife, Maureen, who supported this project from conception to completion, an odyssey of nearly three years. She was with me every step.

– Michael Vitez

Mike Vitez and I once simultaneously crossed America on separate stories, and I always knew we would eventually work together on a "road trip." Little did I realize it would take place right here in Philadelphia, last an entire year, and involve a journey measured not in our highway miles but in thousands of other people's footsteps. I am grateful that he asked me to join him; there is no writer with whom I would rather have spent a year.

I want to thank all of my newspaper coworkers, especially my fellow visual storytelling photojournalists, for inspiring me to see each assignment as a new opportunity. I am grateful for the unabashed openness of every one of the hundreds of Rocky runners we observed, talked to, and photographed. It says a lot in these times that not a single soul was suspicious of our motives. Thanks to Bill Gary at Eckerd Drugs who, with his finely maintained and expertly operated one-hour photo machine, developed all my film and made all the proofs. Nick Pacitti and Debbie Sanfarraro at Best Photo in Cherry Hill, New Jersey, who made all the high-resolution digital scans for layout and all the final color prints. I'm grateful to Paul, John, and Will at Paul Dry Books for allowing me a chance to leave something of my work—besides those boxes of old newspaper clippings—for my children, Madeline and Jesse, who are my greatest joy. And while she might choose a different metaphor, I thank my wife, Michele, who continues to inspire me as much as any of the seventy-two Rocky Steps.

– Tom Gralish

Michael Vitez (left) has been a staff writer at the *Philadelphia Inquirer* since 1985. In 1997, he won the Pulitzer Prize for Explanatory Journalism for his series chronicling the experiences of five people as they approached the ends of their lives. He is a graduate of the University of Virginia, where he was editor of the *Cavalier Daily*, and spent a year at the University of Michigan as a Michigan Journalism Fellow. He has taught writing and journalism at the University of Pennsylvania and Princeton University.

Tom Gralish (right) has been at the *Philadelphia Inquirer* since 1983, working as an editor and a photographer. In 1986, he won both the Pulitzer Prize for Feature Photography and the Robert F. Kennedy Journalism Award for his photo essay on the homeless. Since 1998, he has published a weekly photo column in which he documents everyday life in neighborhoods throughout Philadelphia.